IMAGES
of America

MANISTIQUE

On the cover: This is a typical lumber camp in the winter in Schoolcraft County. (Schoolcraft County Historical Society.)

IMAGES

of America

MANISTIQUE

M. Vonciel LeDuc for
the Schoolcraft County Historical Society

ARCADIA
PUBLISHING

Published by Arcadia Publishing
Charleston, South Carolina

Printed in the United States of America

Library of Congress Control Number: 2009923434

For all general information contact Arcadia Publishing at:
Telephone 843-853-2070
Fax 843-853-0044
E-mail sales@arcadiapublishing.com
For customer service and orders:
Toll-Free 1-888-313-2665

Visit us on the Internet at www.arcadiapublishing.com

*To Dan and Sue White of Portrait's Plus, without whose help
this book would not have been achieved*

CONTENTS

ACKNOWLEDGMENTS

In order to do any historical book covering over 100 years of information, one could not do it without thanking those individuals who researched those years. I would like to acknowledge the research of the following: Alex Meron, Jack Orr, William Crowe, Clint Leonard, the Pioneer Society, and the Schoolcraft County Historical Society. The photographs throughout the book would not have been possible without the courtesy of Jerome Halvorsen and Ann Johnson. Several of the collections from the Schoolcraft County Historical Society were donated. Kathy Tuason donated the Martin H. Quick Collection and Susan Bellville donated the Marcus Bosanic Collection. Throughout the book, other collections will be mentioned, which were donated by those individuals or families. Unless otherwise noted, all images are from the general collection of the Schoolcraft County Historical Society.

Many thanks go to Dan and Sue White of Portrait's Plus, who donated their time and skill to reproduce the images in the book. I would also like to thank Paul Olson and Lisa Demers from the Manistique *Pioneer Tribune* for their assistance and encouragement. Marge Inman and Peggy and Mike Hoffman were my primary support for encouraging me to take on this project. Last but not least, I would like to thank Arcadia Publishing for the opportunity to put our history into a book and appreciate their assistance throughout the process.

INTRODUCTION

Manistique is located in the Upper Peninsula of Michigan on Lake Michigan and is the county seat for Schoolcraft County. Schoolcraft County's original inhabitants were members of the Chippewa tribes. As a result of the War of 1812, the father of Antoine Ossawinamakee was given a portion of Schoolcraft County. Their primary settlement, consisting of 10 to 12 houses, was on Indian Lake, which is three miles from Manistique. In 1833, Fr. Frederic Baraga established his first Native American mission at Indian Lake and converted all but one of the inhabitants to Catholicism. Father Baraga continued his missionary work but visited the Mission Church at Indian Lake frequently. In 1853, he became bishop of Sault Ste. Marie.

Surveys of this section of the Northwest Territories began in our area in the 1820s, and once the surveys were completed, the government began handing out patents (land grants) of our territory from 1848 to 1860. Henry Rowe Schoolcraft originally came to the Great Lakes area as a member of Lewis Cass's survey expedition. The purpose of this expedition was to make topographical survey maps of northern Michigan and the upper Great Lakes. In 1822, Schoolcraft was appointed Indian agent with his headquarters in Sault Ste. Marie and from 1836 to 1841 became superintendent for Native American affairs for Michigan. Besides being known for his writings about the manners and customs of the Chippewa Indians, his most notable achievement to the government was his Treaty of March 28, 1836, with the Native Americans, whereby the United States obtained title to the northern third of the Lower Peninsula of Michigan and the eastern half of the Upper Peninsula.

The first white settlers arrived in the area in 1852 and settled on the east side of the Monistique River (the name Monistique came from the Native American name Onamanitikong, which meant "vermilion"). Their primary occupations were fishing and trapping. The first large patent holder of the area was Charles T. Harvey, who received several thousand acres of the Upper Peninsula as a result of his engineering skills in building the Soo Canal, which opened in 1855. Harvey came to the area in 1860, and since his patent included the mouth and both sides of the Monistique River, he worked with the firm of Spinney and Boyd to supply waterpower to their small lumber mill. Harvey built a dam on the Monistique River in 1860 and named the community Epsport after his wife's family name.

By 1865, Epsport consisted of five buildings and its summer population was around 30. Meanwhile, Spinney and Boyd sold out to Reed, Cutler and Whitbeck, who organized the Chicago Lumber Company. In 1867, Cunningham, Slauson and Deane of Racine, Wisconsin, bought the Chicago Lumber Company. Development of the area was very slow, and in 1870, the town consisted of a small sawmill, a store, a boardinghouse, four dwellings, two lumber slips

400 feet long in the harbor, an additional eight houses, and three board shanties. Mail delivery to the Epsport post office was sporadic to say the least. During the summer, mail came via the vessel *Express* or any others that happened to be coming to the area. During the winter, mail came from St. Ignace via foot using Native American trails. In the late 1860s, the mail was brought to Fayette and in the winter, it took three days to reach Fayette with snowshoes and three days to return to Epsport.

Schoolcraft County was not organized until 1871 and included Alger County with the county seat being Onota. Finally, in 1879, the county seat was moved to Epsport, and in 1885, the boundaries of Schoolcraft County were redrawn without Alger County and remain the same today. When the township of Monistique was organized, an *a* was substituted for the *o*, so Monistique became Manistique at that time.

Epsport, by 1870, still had a population of only 600 people. Finally in 1872, Abijah Weston of Painted Post, New York, partnering with Alanson J. Fox, Martin H. Quick, George H. Orr, William H. Hill, William E. Wheeler, N. P. Wheeler, and John D. Mersereau, bought the Chicago Lumber Company. Initially, it consisted of 10,000 acres of pinewood plus all the river and forest rights from the Charles Harvey patent.

Eventually, the Chicago Lumber Company would own most of Schoolcraft County. The period from 1872 to 1880, began the major development of Epsport. Initially, streets were laid out, an office and company store plus homes were built. In 1876, the old sawmill of Spinney and Boyd was replaced by a new sawmill with three gang saws, a circular saw, two edgers, two trimmers, a shingle mill, and a lathe mill. At the same time, four more slips were built in the harbor and tramways were built to haul lumber from the mill to the slips where they were loaded onto schooners. With the arrival of the "York Staters," mail delivery improved at least during the summer, since the Chicago Lumber Company owned its own line of ships. In 1876, a side-wheeler, the *Union*, made weekly trips to Manistique for both passengers and freight. In 1880, the *Union* was replaced by a steamship, the *M.C. Hawley*, which was able to make two trips weekly. These were extremely important since one forgets there were no roads or railroads, only Native American trails, so the only contact with the outside world was by water.

Initially the Chicago Lumber Company owned almost all of the area including the homes and businesses. The homes were rented to the workers for $4 to $8 a month. Any businesses to come to Manistique leased the property and signed an agreement that no liquor could be on premise since the Chicago Lumber Company wanted to establish a dry city.

With the Chicago Lumber Company's need for employees, immigration began to the area. The York Staters were primarily of English, Scots, and Irish descent. The primary emigrants were from Sweden and Norway, who came to the area with building skills and saw opportunities here. A bridge was built across the Monistique River and the majority of Scandinavians lived on the west side of the river as squatters in an area called Indiantown. Since the area had no plotted streets, houses were built wherever. The squatters paid $1 a month for their leased property.

Because the Chicago Lumber Company could not saw enough timber into lumber, Abijah Weston created a new company, the Weston Lumber Company, in 1882 with the stockholders being the same as the Chicago Lumber Company. The Weston Lumber Company's holdings were on the west side of the Monistique River. Their first mill was built in 1882 where the current Manistique Papers is located, and in 1884, they built an even larger mill at the north end of Weston Avenue (known as Mill Street then). Another dam was built and tramways were extended to the new mills. Both companies had their own offices, stores, and housing. The combined mills produced 90 million feet of lumber a year. These companies employed around 1,000 employees.

One

EARLY DEVELOPMENT

As the Chicago and Weston Lumber Companies were building sawmills and consolidating property in Schoolcraft County, two other companies also operated sawmills in the area. South Manistique was developed by the Hall and Buell Lumber Company, and South Manistique also had its own post office. Jamestown also had a lumber mill, but due to the fact that they had limited timber holdings, they were only in business from 1875 to 1880, when they sold their remaining assets to the Chicago Lumber Company.

South Manistique was located two miles from the current city limits on the west side of Manistique. The Hall and Buell Lumber Company, which later became the Northshore Lumber Company, had the same problem as Jamestown, being that once it cut the trees on its limited holdings, there was no more property to be found. By 1905, the post office closed and the sawmill had been sold to a Nahma firm. The mill was dismantled and moved to Nahma and all of the homes in South Manistique were moved to different locations in Manistique.

Another difficulty for other lumber companies was the fact that the Chicago Lumber Company had set up the Manistique River Improvement Company, which allowed them control of any logs on the river. With this so called "boom" company, they charged other lumber companies a fee for every 1,000 feet of logs.

Manistique was also progressing in other areas at the time. The Manistique Telephone Company was established along with drugstores, banking facilities, and two hotels, the Ossawinamakee and the Hiawatha. The Manistique Telephone Company was established in the early 1890s and had 30 "taps," all of which connected the Chicago and Weston Lumber Companies' operations to the office. Cultural activities took place at the Star Opera House.

The first newspaper was established in the 1870s by Thomas MacMurray and was called the *Manistique News*. Unfortunately, it did not last long. In 1880, the first county newspaper was published by Maj. W. E. Clark and called the *Schoolcraft Pioneer*. In 1882, George E. Holbein began the *Manistique Pioneer*.

In 1881, the Detroit, Mackinac and Marquette Railroad began servicing Seney so Manistique was now connected with the outside world year-round (in order to get to and from Seney one needed to travel via stagecoach).

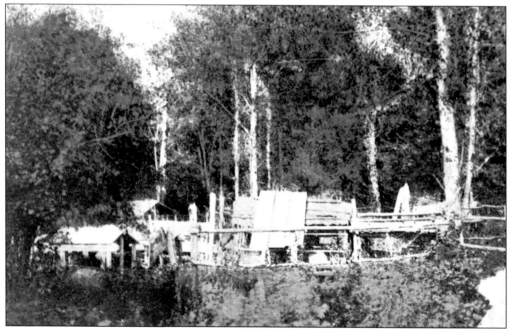

This Native American burial ground was located near Fr. Frederic Baraga's mission church at Indian Lake. Structures were built over the ground to preserve the food left by family members who were providing sustenance for their departed members. Food continued to be given to the departed on special days of the year including religious and harvest celebrations. Semo Ossawinamakee continued to care for this area for many years. (Thompson Township Collection.)

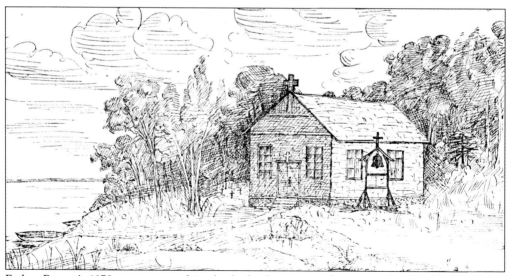

Father Baraga's 1872 mission stood in the little clearing on the eastern bank of Indian Lake. Inside was a center aisle with six or eight rudely fashioned pews with a seating capacity for 50 to 75 people. In front was a small platform with a pulpit. This site has a historical marker to acquaint people with its history. (Marcus Bosanic Collection.)

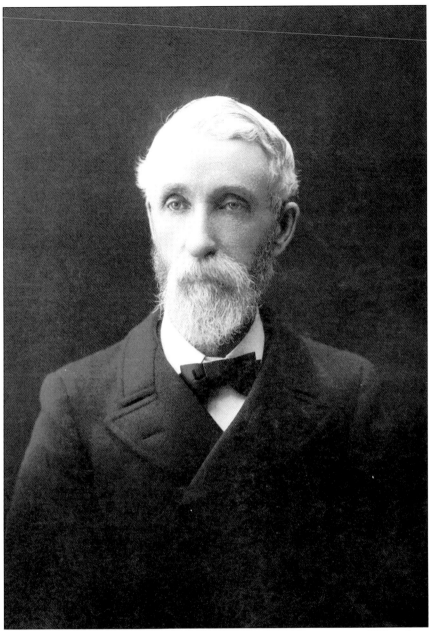

Martin Henderson Quick, a native New Yorker, was sent to Manistique in 1872 to lay out the city and with George Orr to begin harvesting lumber. Interestingly, Martin's official name was Martin H. Quick, the H being only an initial. His new wife, Martha, decided to create a name for the initial, thus Martin Henderson Quick, as he was known in Manistique. As a result of their positions with the Chicago Lumber Company, Abijah Weston gave both Orr and Quick stock in the company and its subsidiaries. Quick's job was general superintendent of the mills, yards, and city property, which he continued until the Chicago and Weston Lumber Companies' sale in 1912. Quick was considered to be one of the most efficient members of the Chicago Lumber Company and its subsidiaries, thus contributing to the Chicago Lumber Company being considered the most efficient lumber company in the Midwest. (Martin H. Quick Collection.)

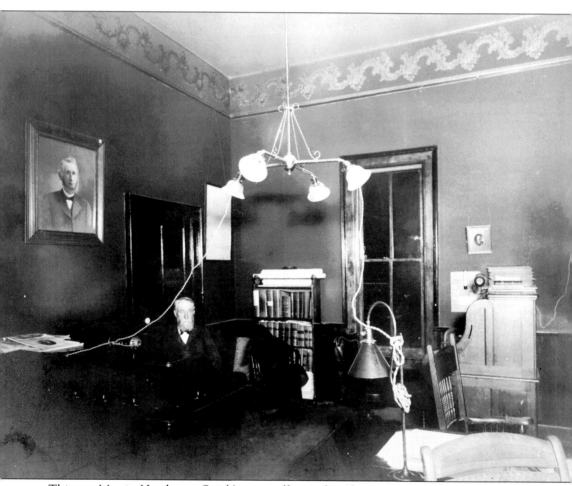

This was Martin Henderson Quick's inner office at the Chicago Lumber Company office. The electrical cords hanging around look a little dangerous. On the left wall is the picture of Abijah Weston, who is called the father of Manistique by many. Weston held 50 percent of the stock in the Chicago Lumber Company with the other 50 percent held by Alanson J. Fox, George H. Orr, Martin H. Quick, William H. Hill, William E. Wheeler, John D. Mersereau, and N. P. Wheeler. He also held majority stock in the Weston Lumber Company and the various subsidiaries he set up. In planning the town of Manistique, the first thing Weston had done was to have all the trees in the area cut down due to the fear of the destructive force of fire. Weston, Fox, and the Wheelers were the only stockholders who did not live in Manistique. Weston made innumerable visits to Manistique from Tonawanda, New York, via the flagship of his fleet of ships, the *Buell*. (Martin H. Quick Collection.)

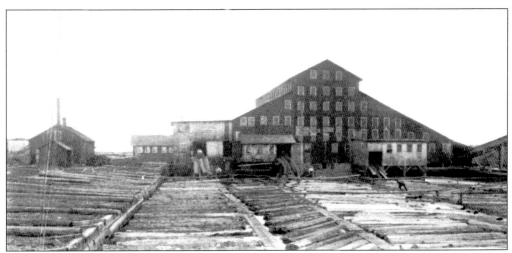

Above is the original gang sawmill built by the Chicago Lumber Company in 1876. The cull logs are on the left riverbank. In the millpond, the first boom had 24- to 30-inch white pine Chicago Lumber Company logs, the second boom had Weston Lumber Company logs, and the third and fourth had mixed logs of Norway, tamarack, hemlock, and jack pine. The Chicago Lumber Company mill pictured below shows the tramway tracks, which moved the lumber to the slips, and also shows the employees at that time. All employees of the Chicago and Weston Lumber Companies were required to sign a waiver saying they would work the number of hours required by the companies even if it was over the 10 hours daily mandated by the State of Michigan. (Above, Ann Johnson; below, Marcus Bosanic Collection.)

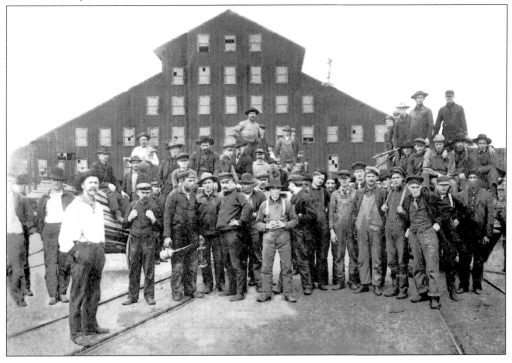

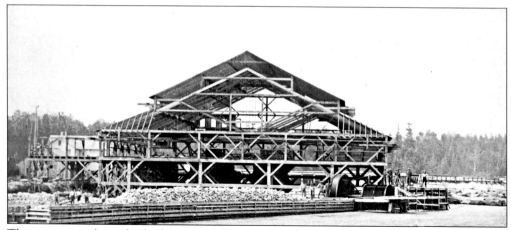

These pictures show the building and completion of the Weston Lumber Company's upper mill, built in 1884 on the Monistique River at the end of Mill Street, now Weston Avenue. This mill was the largest of the Chicago and Weston Lumber Companies' mills. The other Weston Lumber Company mill was located farther south on the same location as the current Manistique Papers. This mill was known as the Bronson Mill and burned down completely in 1907 and was never rebuilt. Between all of the mills of the Chicago and Weston Lumber Companies during the 1890s, the output was 90 million feet of lumber annually. The primary lumber was white pine.

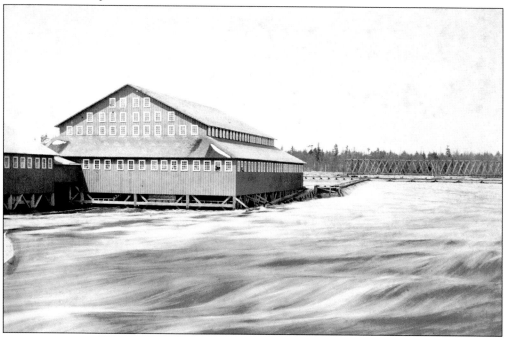

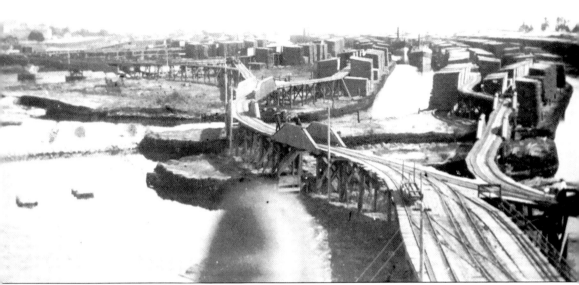

This is an excellent view of Manistique Harbor showing the lumber piles, tramways, slips, and in the background the city of Manistique. The Chicago Lumber Company built additional slips in the Manistique River to facilitate the loading of schooners and barges with lumber. There were six slips in the harbor, which were used as piers for piling lumber and loading the ships. The slips were built by building stone-weighted cribs with pine slabs on the top. They were then tied together and boarded over for more stability, since they would be carrying a lot of lumber piles. The tramways were built to connect the sawmills to the slips. They were built of wood with narrow-gage rails. Originally, horses pulled the wagons of lumber to the slips, but once steam engines came into being, the horses were replaced. (Marcus Bosanic Collection.)

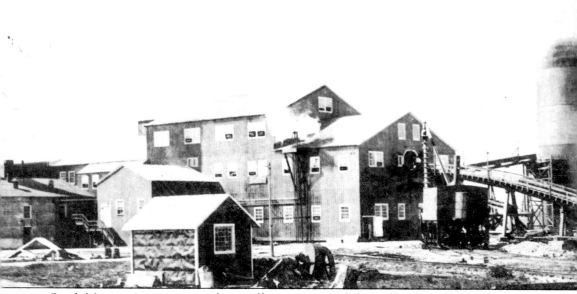

South Manistique as a town and post office arose around the Hall and Buell Lumber Company mill. South Manistique, during the time of the Hall and Buell Lumber Company, had at least 1,000 residents. The lumber rights for Hall and Buell were primarily around Indian Lake. The company cut timber, floated them across the lake to its pull up, and then loaded them onto its railroad to bring to the mill. Hall and Buell had its own docks for shipping out its lumber. The Hall and Buell mill used a band saw to saw the logs, which was much more efficient, faster, and caused much less sawdust waste. Unfortunately, once the company cut all the timber from its patents, there was no more to be found. As a result, South Manistique disappeared by 1905, and the mill was dismantled and moved to Nahma to replace the mill that had burned down.

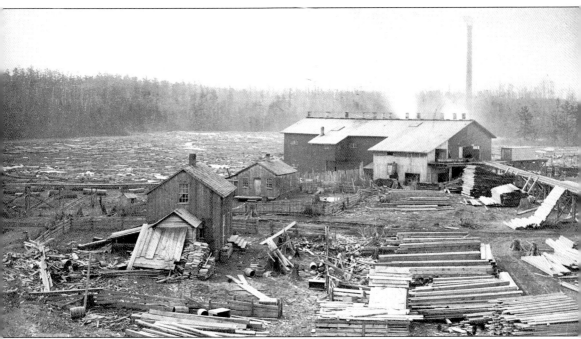

Jamestown was another mill town immediately outside Manistique. The mill was built by Ebenezer James, Constant Ruggles, James Slawson, Eric McArthur, and Dougold McMillan. They held lumber rights in the area of Thunder Lake. Once timber was cut, it arrived at the mill via various creeks to the Indian River then to Jamestown. Once the timber was cut into lumber, it was transported on a horse-drawn railroad to the Manistique docks. The mill ran from 1875 to 1880, when they sold their rights to the Chicago Lumber Company, which dismantled the mill in 1884. Jamestown itself had a disastrous fire that burned all the buildings except the sawmill in July 1878 as a result of an out-of-control forest fire. A few families remained living in Jamestown after the mill closed and many of the employees of the Jamestown mill continued working for the Chicago and Weston Lumber Companies at their mills or in their wood's operations.

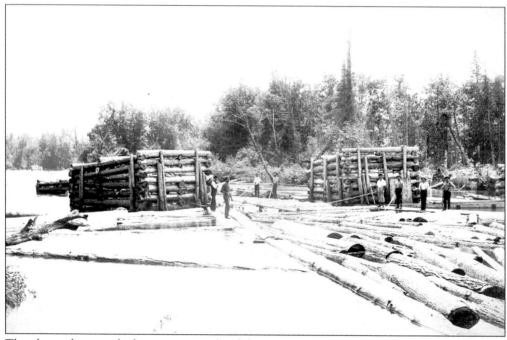

The above photograph shows an example of the cribs that were built in the Manistique River by the Manistique River Improvement Company. They were called sorting gaffs and the men working the gaffs were sorting the logs according to their log marks. All lumber companies had log marks similar to cattle brands that they registered in the counties where they harvested timber.

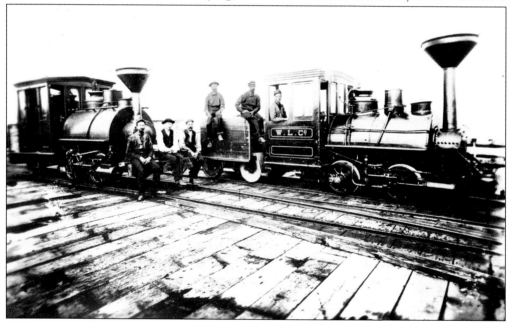

"W.L.Co." can be seen on the side of the engine, which represents the Weston Lumber Company. These steam engines were the replacement for horses when moving lumber from the mills to the slips by way of a narrow-gage tramway. In the background is one of the Weston Lumber Company mills.

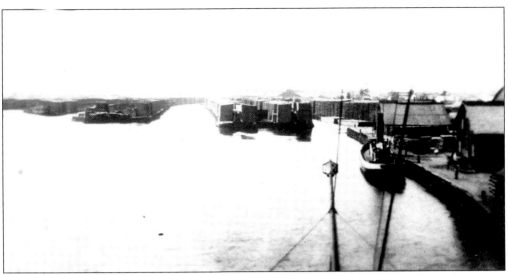

The first commercial fishing fleet out of Manistique was the Coffey fleet. The fish sheds and one of Coffey's fleet of fishing boats can be seen in the foreground. John Coffey moved from Fayette to Manistique in 1880. Whitefish and lake trout were packed in barrels, salted down, and shipped out via schooners to several cities on the Great Lakes. (Thompson Township Collection.)

One of the earliest industries in Manistique was that of commercial fishing. A. Booth and Sons was a group out of Chicago that also ran a fishing fleet out of Manistique. Between the Booth and Coffey enterprises, 75 to 100 men were employed mending and making nets, coopers making barrels, and men working the fishing boats. (Marcus Bosanic Collection.)

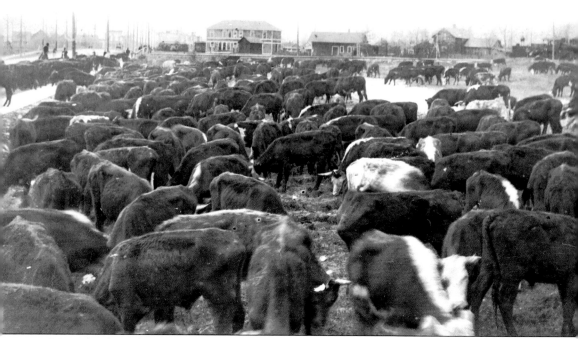

Many families who first came to Manistique in the 1870s and 1880s recall the cows roaming the streets at will and eating other families gardens and the fresh produce in front of the local markets. The cows roamed the boardwalks, upsetting displays and causing people to walk on the dirt streets. One advantage to the free roaming cows was not having to cut grass since the cows kept it under control. Unfortunately, the cows began eating the fresh groceries put out by the markets instead of eating and controlling the grass. The cows were also known to walk through open doorways and cause commotions within those establishments. After *Harper's Weekly* ridiculed Manistique as a cow town, the cows lost their privileges, and ordinances were passed disallowing cows, pigs, and chickens from the so-called metropolitan area. The above picture was taken on the west side of Manistique.

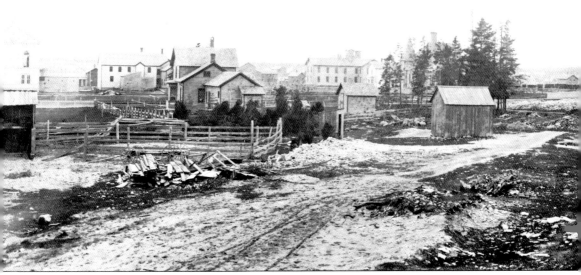

This is a view of the west side of Manistique, showing how this area was originally settled by people squatting on the land and not building according to laid out streets. This is very indicative of Indiantown located a little further south. Indiantown was one of the primary areas where Scandinavian immigrants settled in Manistique. Since they were squatters, they put up their houses and took as much property as they chose. Most of the homes were on cedar posts and were enlarged as the families grew. Most of them had livestock that roamed at will throughout the area. The people continued to pay land rent for the land until 1912 when the Consolidated Lumber Company decided to lay out proper streets and sell the property. By 1916, everyone was evicted and existing homes were moved to other parts of Manistique. Note the muddy pathways and small corrals for holding the family cows. In the right background, Westside School can be seen. (Marcus Bosanic Collection.)

The first county jail and sheriff's residence burned down on January 24, 1884. The two pictures show what the new jail and sheriff's residence looked like in 1885 and how it looked in the 1950s. Part of the courthouse built in 1883 can be seen in the top photograph. The jail was built solidly at the time with six cells on the first floor for male prisoners. The cell doors weighed three and a half tons each. The second floor of the jail had several small rooms for female prisoners. The balance of the jail building served as the sheriff's office, business area, and residence of the sheriff and his family. Finally in 1958, the old jail was torn down and replaced. (Above, Marcus Bosanic Collection.)

The first courthouse building was located on Water Street near the Chicago Lumber Company office. The building was a story and a half high and built high in the air on cedar posts to prevent spring floodwaters of the Monistique River from reaching it. Finally in 1879, the county seat was moved to Manistique after the town of Onota was burned to the ground. In 1881, the Chicago Lumber Company gave the city an entire block upon which to erect a new courthouse and jail. The courthouse at right was built in 1883 but was totally lost to a fire in March 1901. The picture below shows the courthouse from a different angle with a few houses near it. (Marcus Bosanic Collection.)

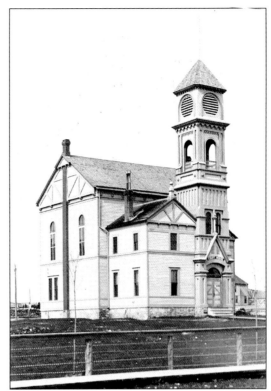

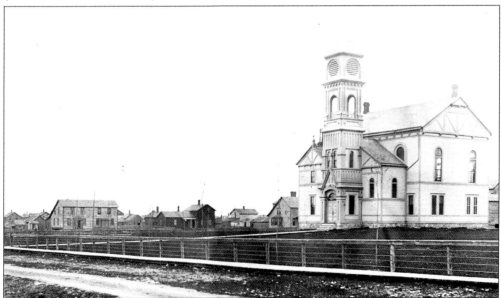

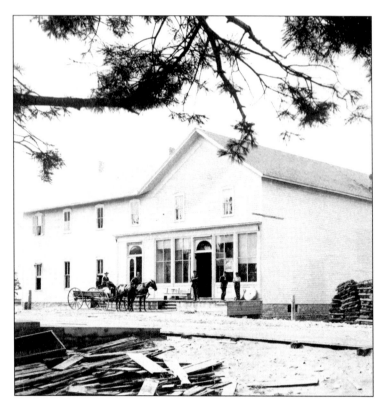

This is the first building built in Manistique by the Chicago Lumber Company in the 1870s. The building served as the office, the Chicago Lumber Company store, and as a boardinghouse. Eventually, other housing was built, along with a larger store to accommodate the increasing population of Manistique. (Marcus Bosanic Collection.)

The Chicago Lumber Company constructed many buildings. The one above was located at the harbor and served as a warehouse for goods brought by Abijah Weston's ships. The warehouse was quite large because it had to store all of the goods and supplies needed for a winter, since initially Manistique in the winter was cut off from supplies coming into the area since there were no roads or railroads, only water for transportation.

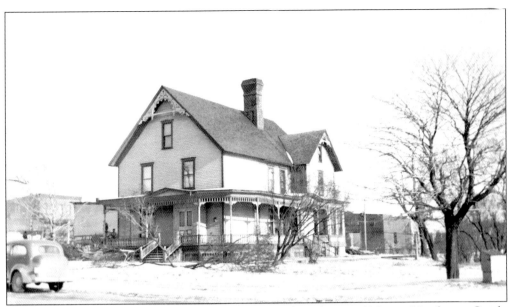

One of the first houses built in Manistique was the above home of Martin Henderson Quick. The house was located across from the Chicago Lumber Company office and also had a view of Manistique Harbor. The house remains but has changed into a motel office, and instead of an open area to the left of the house, a post office now stands. (Martin H. Quick Collection.)

Besides establishing a community, the "York Staters" felt education was absolutely necessary. The above building was the first school constructed in 1872 and sat across from the Chicago Lumber Company office. It initially ran as a three-month school and was replaced by a larger facility in 1881.

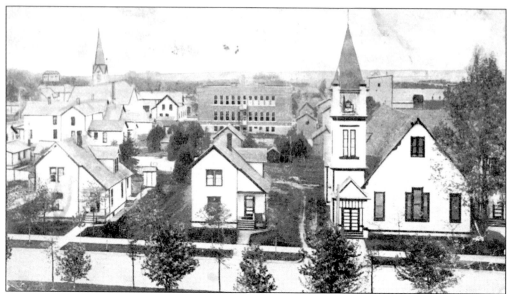

The church on the right was the first church built in the community. The York Staters were a very religious group of men. In fact, upon his arrival to Manistique, Martin Henderson Quick and his wife held a Sunday school on their first Sunday in Manistique. The First Baptist Church was built in 1882 and has served the community ever since. (Pioneer Tribune Collection.)

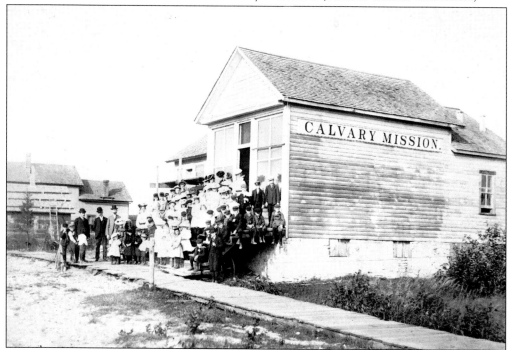

Once the west side of Manistique began being developed by the Weston Lumber Company, Martin Henderson Quick wanted to have religious services on Manistique's west side. The Calvary Mission, which was an offshoot of the First Baptist Church, was organized in 1897. The church had several locations until 1910, when the above building was built with Martin Henderson Quick funding a large part of the building.

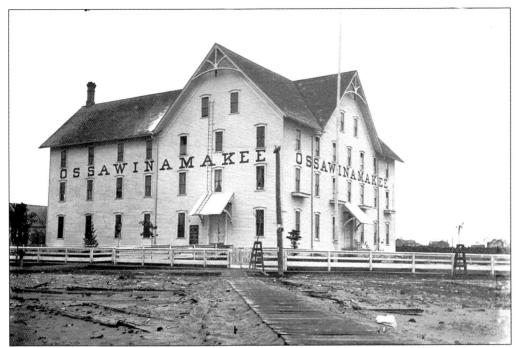

Probably the best-known hotel not only in Manistique, but throughout Michigan, was the Ossawinamakee Hotel, which opened in 1883. It was built and owned for many years by the Chicago Lumber Company. The hotel was a grand, four-story structure with a boardwalk that ran to the harbor so arriving passengers could walk to it or they could choose to ride a horse-drawn taxi.

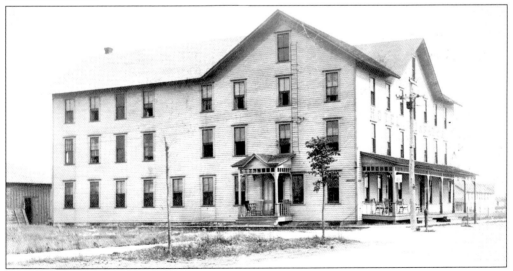

As the west side of Manistique developed, the Weston Lumber Company built the Hiawatha Hotel across from the Minneapolis, St. Paul and Sault Ste. Marie Railroad (Soo Line) depot. The Hiawatha Hotel was an exact replica of the Ossawinamakee Hotel. The primary customers were salesmen. One thing different from the Ossawinamakee Hotel was its three-story outhouse (the only one in town). To reach it, there were walkways from the second and third floors and the walkways were what supported the outhouse.

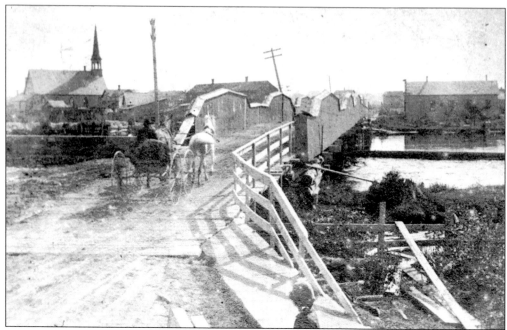

This is a picture of the first bridge built across the Manistique River in 1874. It was built higher than the dirt road since logs were floated under it to reach the sawmills. The sidewalls were built up for safety's sake since traffic was either by foot, bicycle, or horse. In the background are buildings on the east side of Manistique.

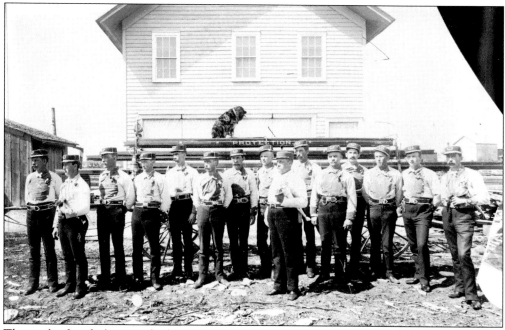

This is the first firehouse, which was located at the bottom of Main Street on the east side of Manistique. Up until 1885, fires were fought primarily with buckets. Finally in 1885, two hand engines, two hose carts, and a hook-and-ladder cart were purchased. The volunteer firemen above are pictured in front of a hose cart at the fire department building. (Jerome Halvorsen.)

Two

THE LOGGING ERA

Abijah Weston originally sent George H. Orr to Manistique to begin securing additional property and to set up the logging operation for the Chicago Lumber Company. With this initial assignment, he was given a 5 percent share of the Chicago Lumber Company. Orr held the title of woods superintendent for 40 years. (Incidentally, Orr's six brothers also came to Manistique, some worked for the Chicago Lumber Company and others started their own businesses in the community.)

The job of woods superintendent was a huge undertaking since three sawmills needed to be supplied. Orr supervised all facets of the logging enterprise from building roads, locating camps, and checking that logging camps were running at peak capacity. Through his hard work and planning, he was able to keep a two-year supply of logs in the Manistique River and Indian Lake. During the summer months, "landlookers" or timber cruisers were employed to estimate timber supplies in order for Orr to appropriately place lumber camps for the winter's cutting. Each season the Chicago and Weston Lumber Companies ran nine camps a season along with several camps run by individual jobbers. The horse teams for the Chicago and Weston Lumber Companies were summered at the Indian Lake Ranch run by Abner Orr.

Also, during the summer months, once camp locations were chosen, roads were then mapped out. The main road would be about 20 feet wide and usually meandered a lot since they would try to keep as level a grade as possible by going around hills. Once freezing weather set in, men would use water tankers to ice down the roads, then a rut cutter would cut four-inch, parallel ruts for the sleighs carrying logs. Road monkeys were individuals who put sand and hay on the ruts to slow the sleighs down when coming down grades. All of the lumber camp employees who were part of the road crews worked during the night, plowing and preparing roads throughout the season.

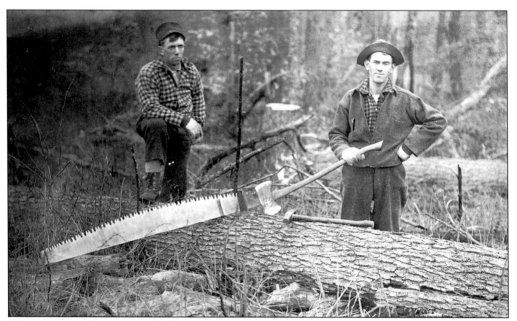

This is a team of sawyers with their crosscut saw and other tools of the trade. Prior to the 1880s, trees were felled with a four-man crew: two men called choppers using double-edged axes and two men called swampers trimming the limbs and cutting the bark on one side. The crosscut saw came into being in the 1880s and replaced the ax as the primary cutting instrument. (Adolf Sandberg Collection.)

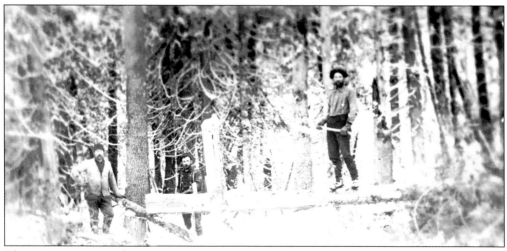

The cutting crew in the 1880s was comprised of three men: the timber fitter, who notched the tree and determined where it would fall, and two sawyers, who then cut the tree. This three-man crew would cut approximately 15 trees a day, making 75 logs, 20 feet long. (Marcus Bosanic Collection.)

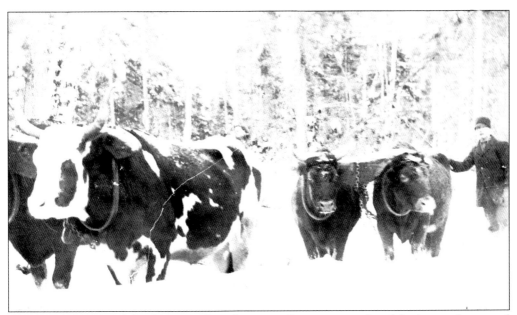

Originally hauling of the logs was done by oxen. Oxen were replaced by horses for several reasons. Oxen required special equipment to shoe them. When one raised one hoof, they would fall down, so blacksmiths had to have a hoist to hold the oxen in order to shoe the four hooves. It was also found that horses could handle larger loads of logs.

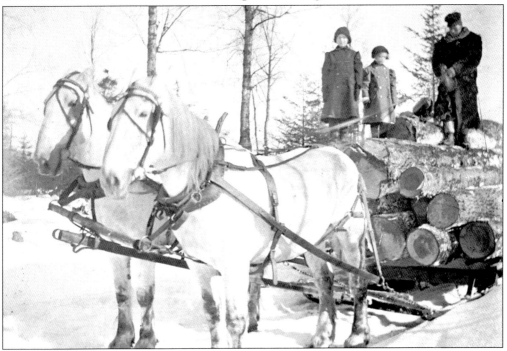

The author's grandfather is seen here with his two daughters on a sled with his matching white workhorses, indicative of loads customarily pulled by horses. Once ice roads were in place, horses proved to be more efficient to pull sleighs of logs to the log dumps. The picture is from 1910. (Adolf Sandberg Collection.)

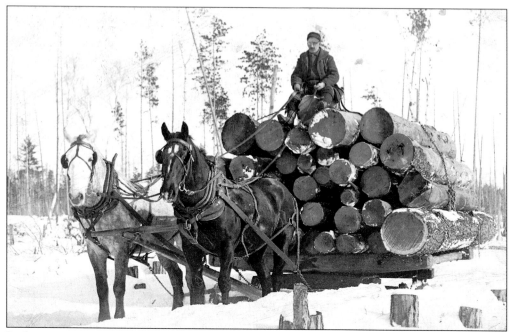

By having two sets of ruts cut into the ice roads and using sleighs, the amount of logs easily moved proved to be amazing. The largest load of logs ever pulled by a team of horses was 50 logs totaling 36,000 board feet of white pine. This load became part of the Michigan exhibit at the World's Columbian Exposition in Chicago in 1893. (Normie Jahn Collection.)

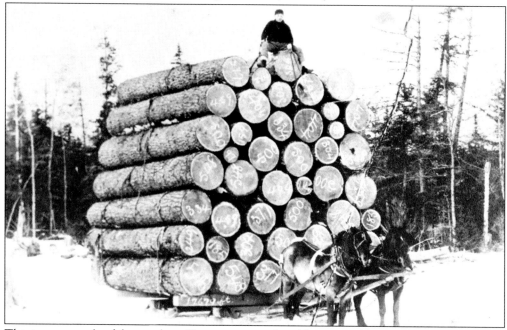

This is an example of the number of logs one team of workhorses could pull. The logs are marked on one end showing the number of board feet per log. On the other end, would be the log marks of the company or individual jobber, so these logs could be identified once they reached the sawmill. (Marcus Bosanic Collection.)

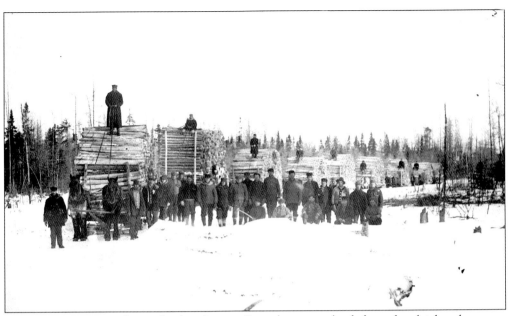

These two pictures refer to the log dumps. Once logs were loaded on the sleighs, they were transported to a log dump. The log dumps were originally along a riverbank. Trees were cut in close proximity to a river, which would be used in the spring to bring the logs to the sawmill. If the ice was deep on the rivers, the log dump would be located on the river so they would automatically fall into the river at spring breakup. As time progressed and timbering operations moved further away from rivers, railroads came into prominence. At that point, the log dumps would be located near the train tracks to be loaded on railroad cars for transport to the sawmills.

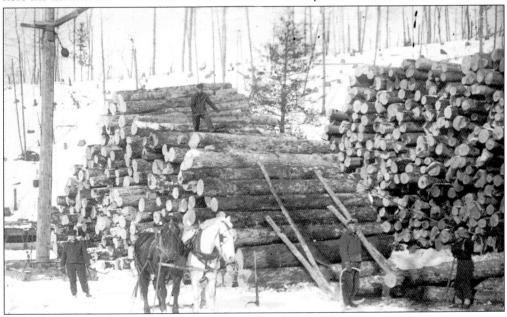

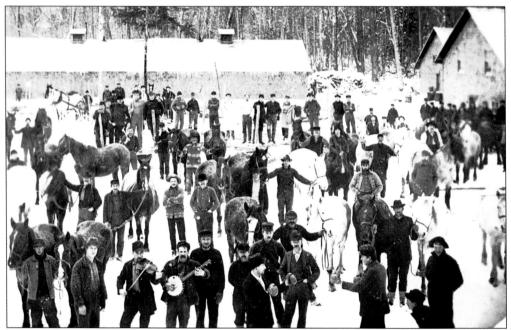

Lumber camps were usually constructed in three or four days. They were comprised of a cook camp; men's camp; barn, hay, and grain storage sheds; a blacksmith shop; and an office. The men's camp was a log structure with double bunk beds on each side made out of rough lumber with hard board bottoms covered with hay or straw and had coarse wool blankets with no pillow. In place of a pillow would be a "turkey," a grain bag filled with the lumberjack's clean clothing. In the middle of the men's camp would be a large stove for heat and drying out clothing. Lumberjacks worked six days a week from before dawn to dusk. Evening hours were spent sharpening their tools, playing cards, or reading. Most camps had lumberjacks who played various instruments—fiddles, harmonicas, and accordions were the most common—which came out on Saturday nights. (Above, Marcus Bosanic Collection; below, Adolf Sandberg Collection.)

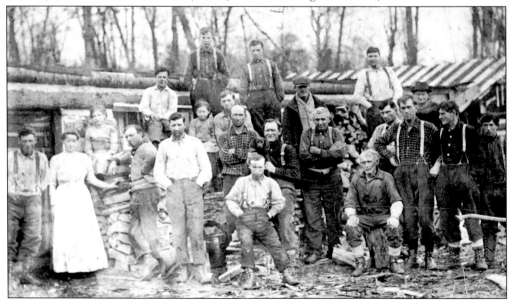

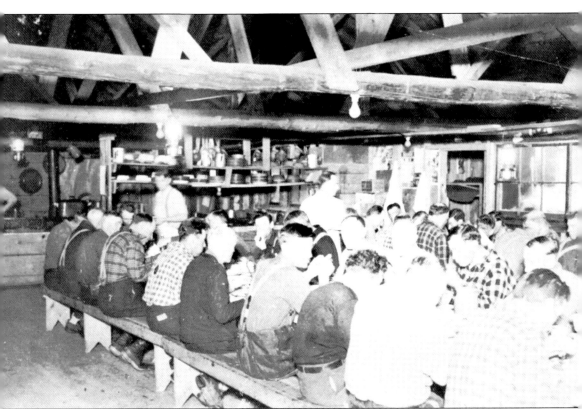

The cook camp had a cook stove, pump and sink for water, food storage area, and tables with benches for the men to eat their meals. The cook lived in the back of the cook camp. If the camp was large enough, the cook might have assistants, called cookies. Lumberjacks required hearty meals three times a day; they were called into the cook camp using one of three methods: banging pans together, hitting an iron bar with a hammer, or blowing the camp horn. When lumberjacks were working close to the camp, they came in for their lunch meal, but as they moved further away, it was the cook's responsibility to bring their meal to them. Lunch usually was comprised of salt pork, corned beef, potatoes, and vegetables, with dinner comprising leftovers and various soups. Wages for lumberjacks varied depending on their job. The best paid were the cooks at $50 a month. Sawyers, timber fitters, skidders, and log deckers received $30 a month, swampers received $24 a month, and teamsters received $45 a month. (Ann Johnson.)

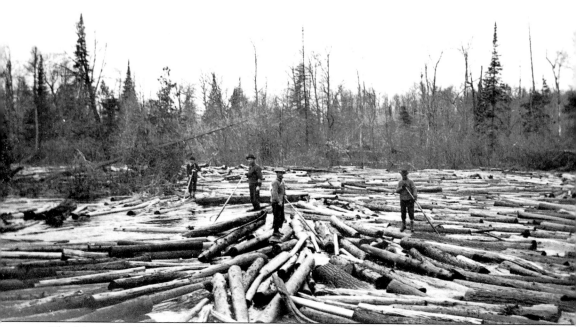

The Manistique River watershed is comprised of several lakes and rivers that cover an area of approximately 1,500 square miles. The rivers and streams were dammed prior to the spring melt in order to create the floodwaters to move the logs down the rivers and streams. River driving was the most dangerous of all lumber jobs. Not all lumberjacks participated in river drives. River drivers, or river hogs, were the highest paid at $10 a day plus room and board. The river hogs rode the logs down the river trying to keep them going straight, but occasionally a logjam occurred, which would usually need to be dynamited. Following the river drivers was a cook raft or wanigan. These were built of 36 foot cedar logs lashed together then flooring was placed over the logs. The wanigan was controlled by one large oar at each end of the raft. Usually half was the cooking area and the other half served as a bunkhouse. River drives usually took at least 40 days.

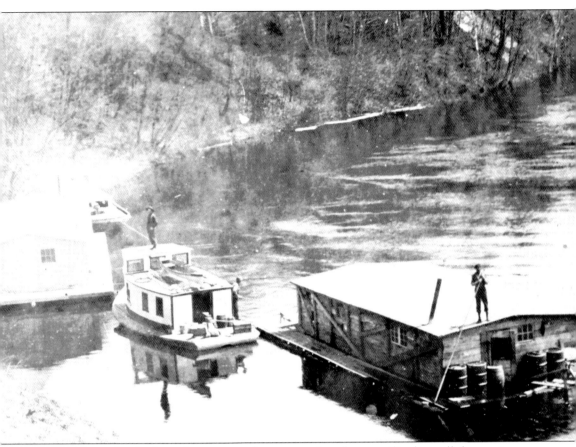

By the early 1900s, the *River Queen*, a gasoline-powered craft, was utilized to pull the wanigans. A special craft was created for moving logs on Indian Lake to the Indian River, which drained into the Manistique River. This craft was named the *George H. Orr* but became known as the "Mud Hen." It was built in 1872, was 35 feet long, and was propelled by a steam engine driven side-wheel. Its job was to pull a raft of logs across the lake to the Indian River. The crew consisted of seven men who lived aboard and worked all summer. By 1896, the woods operations had moved away from rivers so logs were carried by railroad to the sawmills. As a result, the Mud Hen ceased being used. (Marcus Bosanic Collection.)

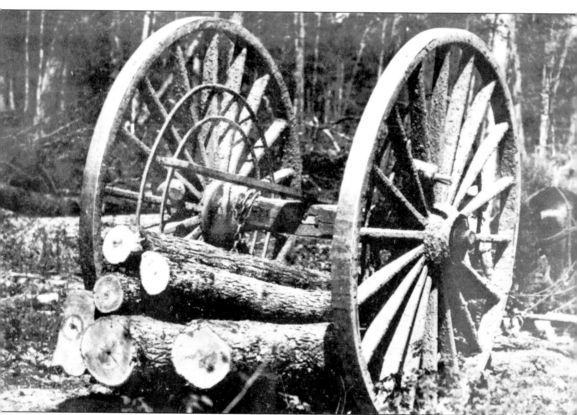

The big wheels shown above were used to snake logs out to loading sites and were pulled by a team of horses. These wheels were 10 feet high. These big wheels were used primarily in swampy areas and also by loggers who continued logging throughout the spring and summer. Basically, the only way to move logs after spring breakup was by utilizing the big wheels. The majority of loggers worked during the winter months and upon returning to town worked in the sawmills or were farmers. (Ann Johnson.)

Three

INDUSTRIAL
DEVELOPMENT

During the 1880s, Abijah Weston added enterprises to the community. He brought George Nicholson from Wisconsin to form the White Marble Lime Company in 1889 and begin utilizing the vast resource of limestone found in the area. The operation was initially set up in Manistique and used charcoal to heat the limestone in order to create quicklime. They contracted with the Chicago and Weston Lumber Companies to take all the cedar that Nicholson used at his cedar mill, which he built in 1896. This mill manufactured cedar shingles and railroad ties. The maximum production was 200,000 shingles and 15,000 ties a day.

In 1887, Weston set up the Manistique Iron Company and in 1890 the Weston Furnace Company. These companies had most of the same board members as the original Chicago Lumber Company. This was the beginning of the charcoal iron production in Manistique. These companies were located on Furnace Street, now North Cedar Street, on the east side of the Manistique River. Iron pellets were brought to Manistique and melted, utilizing charcoal, into pig iron.

Other industries that came and went during the early part of the 20th century were the manufacture of potash, cant hooks, brooms, sauerkraut, and cigars.

During the late 1880s, transportation improved with railroads, car ferries, and additional roads with the beginning of the personal motorized vehicle. Manistique, with its harbor open year-round, became a major hub of industrial activity through the 1930s. As a result of the Chicago and Weston Lumber Companies cutting of all of the timber, subsidiary businesses to the lumber business continued, but once this resource was gone and not restored, the industrial development of Manistique diminished. Once the Chicago and Weston Lumber Companies saw the end of the lumber era in Manistique, they sold their assets in 1912 and moved their operations to Washington and California.

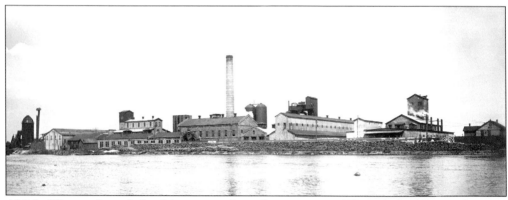

Abijah Weston formed the Manistique Iron Company in 1887 and the Weston Furnace Company in 1890. These industries were located at the north end of Furnace Street, now North Cedar Street. Charcoal was made in beehive-type buildings and then used in the furnaces to melt iron ore pellets and make pig iron, which was shipped throughout the United States. The Burrell Chemical Company bought the above companies creating the Lake Superior Iron and Chemical Company. By 1913, the Lake Superior Iron and Chemical Company was foreclosed upon due to a soft iron market. In 1915, a new company was formed by American, Canadian, and British interests and called the Charcoal Iron Company of America. The company remained in business until 1923 when the business declared bankruptcy. (Above, Marcus Bosanic Collection; below, Ann Johnson.)

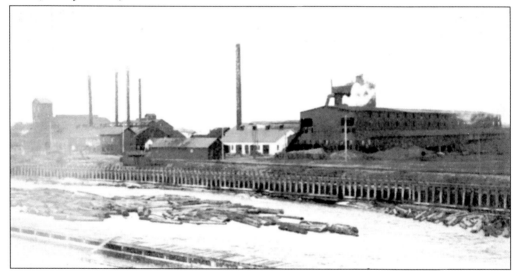

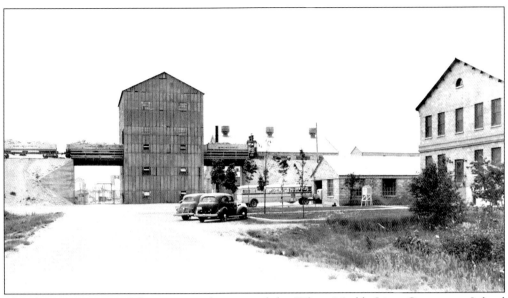

The above picture is of the successor business of the White Marble Lime Company—Inland Lime and Stone Company. George Nicholson was brought to Manistique to partner with Abijah Weston in 1889 to form the White Marble Lime Company. The initial area utilized for the manufacture of lime was a large area along Maple Street. Kilns were used to heat the crushed limestone to make quicklime. George Nicholson also built a shingle mill in 1896, which manufactured cedar shingles and railroad ties. Nicholson also expanded his limestone operation to areas called Marblehead and Calspar. In 1928, Inland Lime and Stone Company acquired the Calspar area from the White Marble Lime Company and built the above plant and docks at Port Inland. (Above, Ann Johnson; below, Marcus Bosanic Collection.)

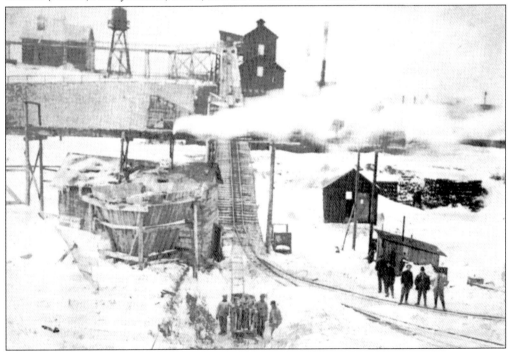

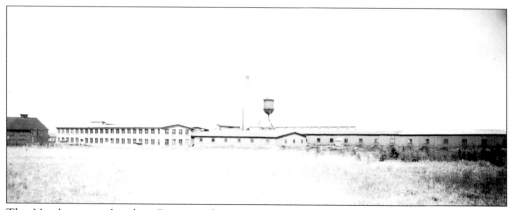

The Northwestern Leather Company began its career in Manistique as the Federal Leather Company in 1884 and was owned by the Bullivants of Boston. The original factory was built near Jamestown Slough and the area became known as the "Tannery" and employed 120 men. The hides came from South America. The Tannery closed in 1922, was put on the market for sale in 1924, and all but two brick buildings were destroyed by fire in 1925. (Marcus Bosanic Collection.)

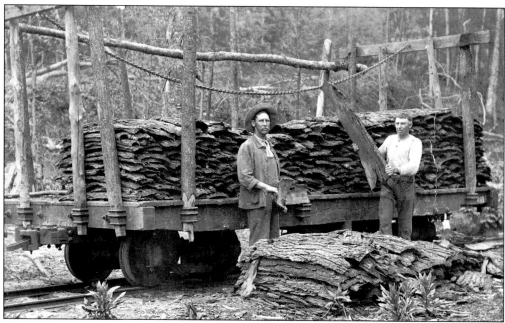

These men are loading hemlock bark onto a railroad car for use at the Tannery. Only eastern hemlock was used for tanning hides. The trees were cut in the fall and by spring the bark was able to be removed. Once the bark arrived at the Tannery, it was left to dry. Once dry, the bark was ground into granules and then utilized in the tanning process. (Clint Leonard Collection.)

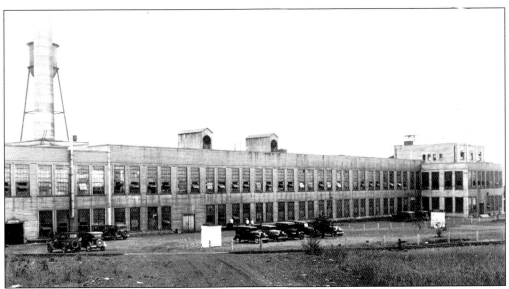

The Manistique Pulp and Paper Mill was built by W. J. Murphy, who owned the *Minneapolis Tribune*. Property by the Manistique River was bought along with the Manistique Light and Power Company. Construction began in 1916. The location of the mill was on the site of the first Weston Lumber Company sawmill, which had burned down in 1907. The siphon bridge with the huge flumes were designed to increase power production for not only the mill but for the city of Manistique. Because of the flood in March 1920, the mill finally began production in May 1920. The mill was sold in 1942 to the Mead Corporation and in 1952 to Kearney. The name was changed to Manistique Papers, Inc., in 1960 when Field Enterprises bought the mill. (Above, Ann Johnson; below, Hulshof Collection.)

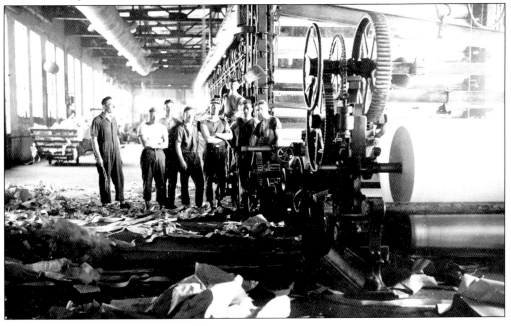

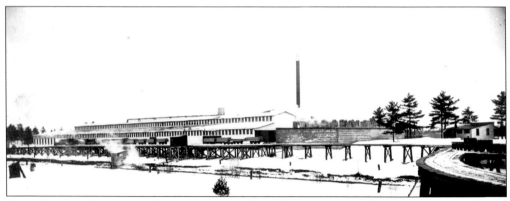

Brown Lumber Company of Traverse City purchased property south of the Manistique Pulp and Paper Mill from the Consolidated Lumber Company in 1915. The Brown Lumber Company had a flooring mill, woodworking machinery, clamp rooms, a saw filing room, warehouses, and loading docks for railroad cars. The company also added a sawmill in the 1920s. During its initial phase, it made bacon boxes for the war effort and after the war returned to the production of running boards and other automobile parts (sills, door frames, and windshield bars). In 1929, the Bay De Noquet Company of Nahma bought the company and changed the name to the Brown Dimension Company. In 1941, the name was changed to the Michigan Dimension Company. The Michigan Dimension Company was liquidated in 1952 with all its assets then sold at public auction. (Marcus Bosanic Collection.)

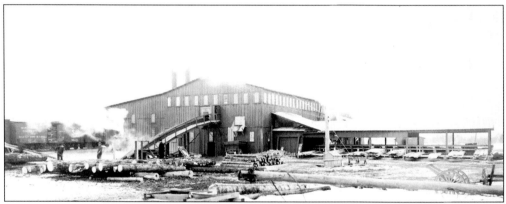

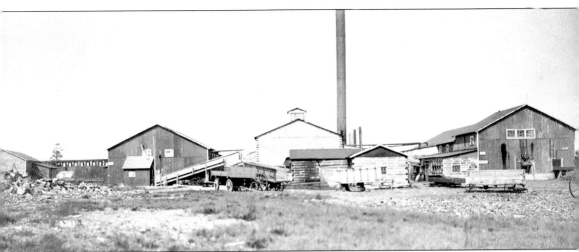

The Manistique Cooperage was in business in Manistique from 1914 to 1922. Its plant was located on North Houghton Avenue by the Soo Line Railroad tracks. The Cooperage manufactured barrel and cask ends, which were used primarily as nail kegs. The barrel ends were the only part produced here and they were then shipped to Pittsburgh for final assembly of the barrel. The business was owned by the Greif brothers. The end of the company came as a result of a fire in the kilns that got out of hand, destroying most of the operation in 1922. After the burning of the Edwin Bell Cooperage Company in Engadine, that firm moved to Manistique and operated in the old Manistique Cooperage buildings that remained. (Marcus Bosanic Collection.)

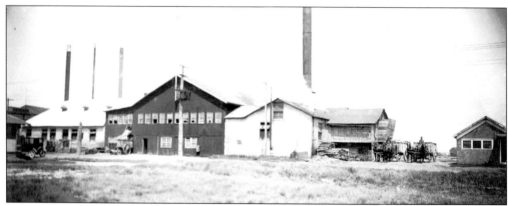

The Manistique Handle Company began operations in 1912. It originally manufactured broom handles and other wood items used for floor sweepers, dowels, feather duster handles, and whisk broom handles. The primary woods used were maple and beech. It supplied several companies and prison operations with a monthly production of between 35,000 and 40,000 handles. The Thomas Berry Chemical Company owned it for several years and employed 30 men in the plant plus 30 in the wood's operation. In 1929, it was sold to Charles Slining Sr., who renamed it the Northwoods Manufacturing Company and manufactured handles for brooms. The handles were made from maple, birch, and beech. At peak times, the factory produced 30,000 handles a day. The plant closed in 1954 and the buildings were torn down. (Above, Marcus Bosanic Collection.)

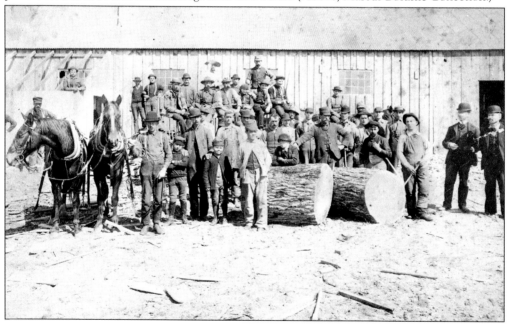

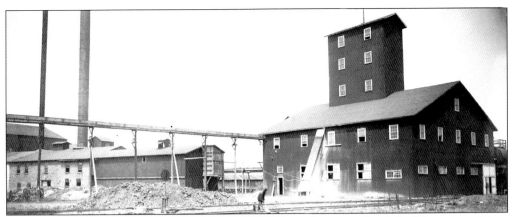

The Thomas Berry Chemical Company was located on the east side of the Manistique River, not far south of the siphon bridge. The chemical company operated from 1916 to 1925. It initially produced chemicals for the war effort. Its primary products were acetates, wood alcohol, and other products that could be distilled from wood. The Thomas Berry Chemical Company was also the second owner of the Manistique Handle Company. (Marcus Bosanic Collection.)

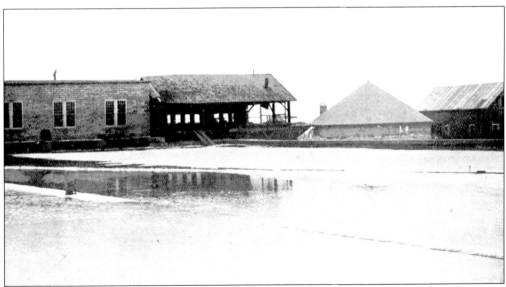

The Manistique Light and Power Company was originally located on the west side of the Manistique River. Benjamin Gero Sr. bought the company in 1898 and built a new water power plant on the east bank of the Manistique River. Manistique Light and Power Company was sold to the Minneapolis Tribune in 1916. The paper mill later sold the power company to Edison Sault Electric Company. (Marcus Bosanic Collection.)

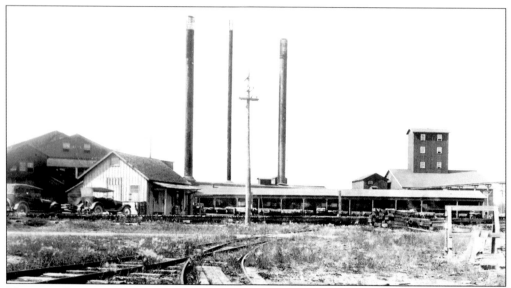

The sawmill pictured above was the original Chicago Lumber Company mill, built on the east side of the Manistique River. In 1912, William Crowe and Louis Yalomstein bought the assets of the Chicago and Weston Lumber Companies and named their enterprise the Consolidated Lumber Company. The Consolidated Lumber Company ended in 1926 with whatever assets they had retained being sold in a liquidation sale. In 1922, the Stack Lumber Company bought the Consolidated Lumber Company's sawmill, tramway system, and property on the west side of the Manistique River. The company employed 100 to 120 men in its operations. By the 1930s, the Stack Lumber Company dismantled and sold the sawmill and abandoned the other properties. The steel bridges and rails of the tramway were sold to a local junkyard. (Above, Ann Johnson; below, Jerome Halvorsen.)

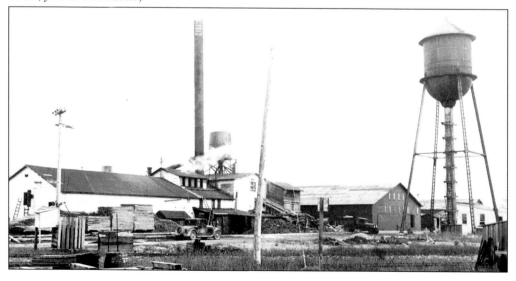

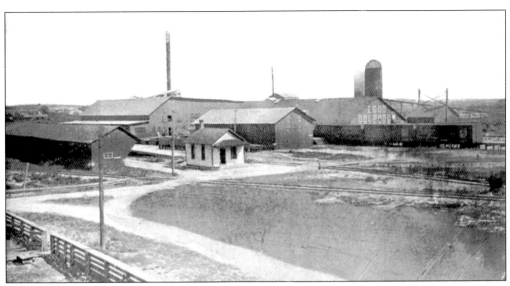

The Goodwille Brothers Box Factory was built in Manistique on the west side of the Manistique River. The Goodwilles were from the Chicago area. The factory manufactured wooden boxes and crates to customer specifications. The plant operated from 1907 to 1920, when the flood caused extensive damage to the buildings and caused many finished boxes to end up in Lake Michigan. As a result of the damage, the plant was never repaired and reopened. In 1925, the Robbins Flooring Company purchased the plant and dismantled it. The picture below shows some of the workers in the box factory. (Ann Johnson.)

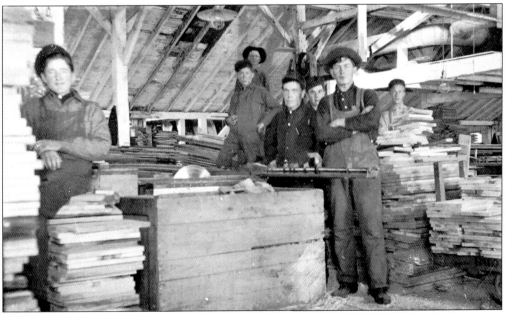

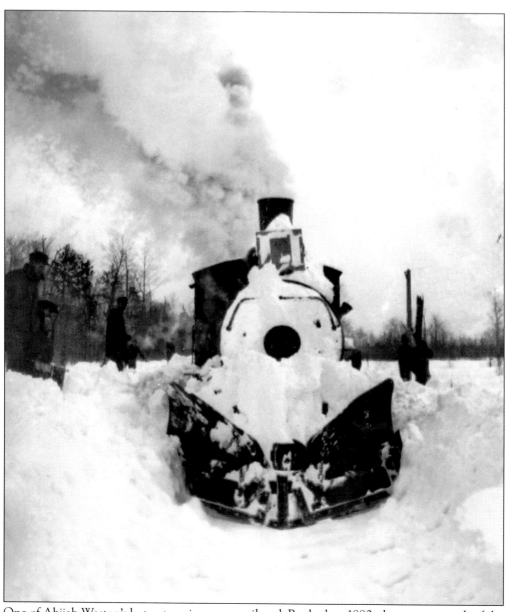

One of Abijah Weston's last enterprises was a railroad. By the late 1880s, because so much of the timber had been cut, continuing to use the rivers as the main source of transporting logs was becoming an inadequate system. Building a railroad into northern Schoolcraft County would serve two purposes for Weston: one, to reach more timber and two, to connect the Weston Furnace Company directly with the iron ranges. In 1891, the State of Michigan granted a charter for the Manistique and Northwestern Railway Company. The railway began as an extension of the Hall and Buell line from South Manistique. The railroad had many names throughout its history: the Manistique, Marquette and Northern (1902), the Manistique and Northern, and in 1909, its final name, the Manistique and Lake Superior Railroad Company. It was locally called the Haywire and ran to Shingleton where it connected to the Duluth, South Shore and Atlantic Railroad. The Haywire carried freight and passengers until 1968, when it stopped forever. (Marcus Bosanic Collection.)

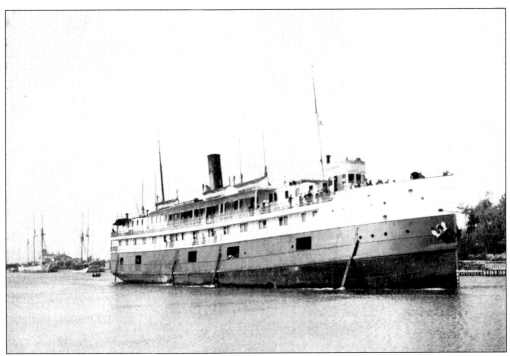

This shows a car ferry in Manistique Harbor. At one time, Manistique had two railroad car ferries servicing the area. The Manistique, Marquette and Northern had a car ferry called the *Manistique* in the early 1900s (the only Upper Peninsula railroad to run a car ferry). The *Manistique* sank in 1908 at the Chicago Lumber Company dock, but was repaired and sold to another company, which renamed it the *Milwaukee*. Unfortunately, it sank in 1929 near Grand Haven with all hands on board. The Ann Arbor car ferries operated out of two ports in Wisconsin (Kewanee and Manitowoc) and two ports in Michigan (Manistique and Frankfort). The lower picture shows another of the Ann Arbor ferries in Manistique Harbor.

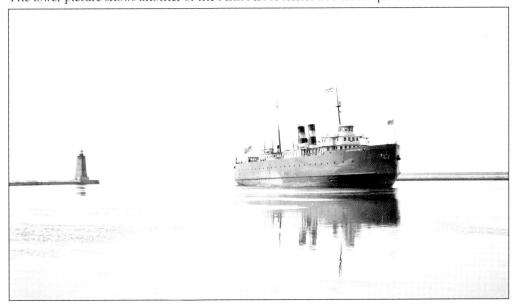

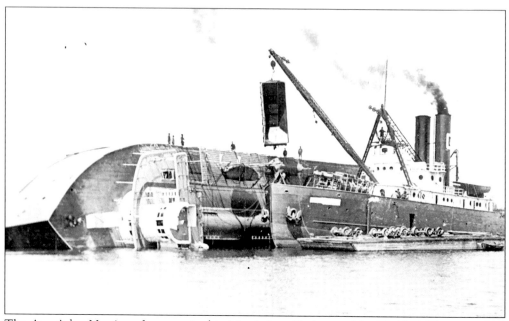

The *Ann Arbor No. 4* car ferry capsized in Manistique Harbor on May 29, 1909. The procedure for loading the railroad cars of iron ore was to load the center two tracks first then the outside tracks. Apparently, the inside tracks were loaded properly but then the port side track was loaded causing the ferry to list and capsize. The top picture shows the tug *Favorite* using a crane to pull the railroad cars out of the car ferry after its hull plates were removed. The lower picture shows the railroad cars being removed from the back of the car ferry. The *Ann Arbor No. 4* was repaired in Milwaukee and back in service by the fall. By 1968, the Ann Arbor car ferries ceased their operation in Manistique and ceased operations totally in 1982. (Above, Marcus Bosanic Collection; below, Jerome Halvorsen).

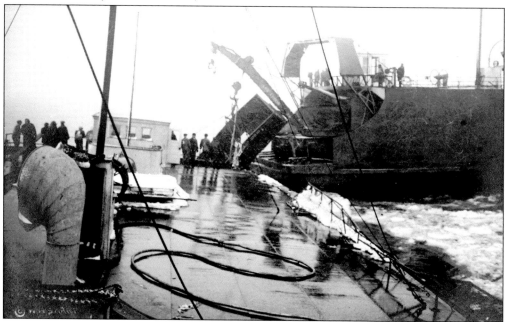

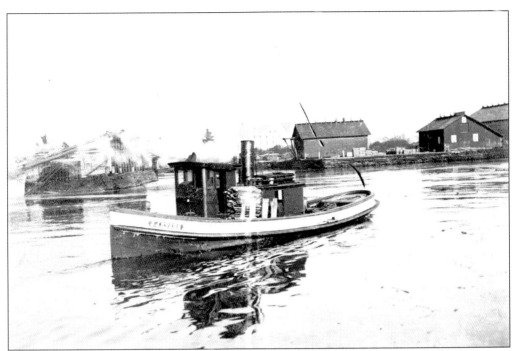

Both of these pictures show tugs in Manistique Harbor in different time frames. The one above was named the *J.J. Evans*. Probably the one best known was the *Gifford* under the command of Captain Garrett. One role of the steam tug was to dock the schooners at the different slips for loading and then return them into Lake Michigan. The tugs also went out into the lake and brought in barge tows to be loaded and returned to the barge, which then transported the lumber to the marketplace. The barge line was owned by Abijah Weston and it was called the Tonawanda Barge Line, which had a fleet of 12 ships. (Above, Marcus Bosanic Collection; below, Thompson Township Collection.)

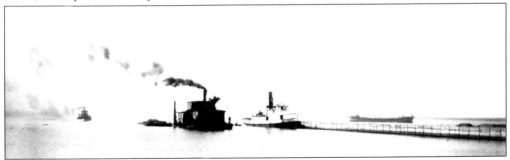

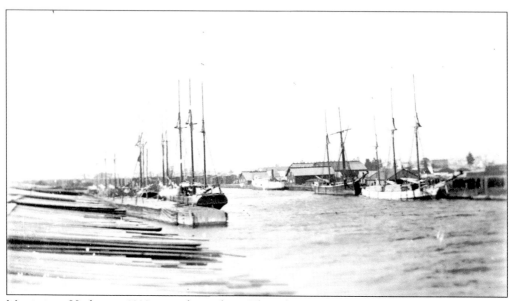

Manistique Harbor in 1892 was a busy place. The schooners were built with wide beams so as to maximize the amount of weight they could carry. Manistique Harbor was not only served by the lumber schooners and the Tonawanda Barge Line, but it was also served by passenger lines, freight lines, and car ferries. Some of the ships long ago forgotten that brought mail, freight, and passengers were the *Hawley*, the *Hart Line*, the *Messenger*, the *Dove*, the *Ivanhoe*, and the *Van Raalte*. (Above, Marcus Bosanic Collection; below, Ann Johnson.)

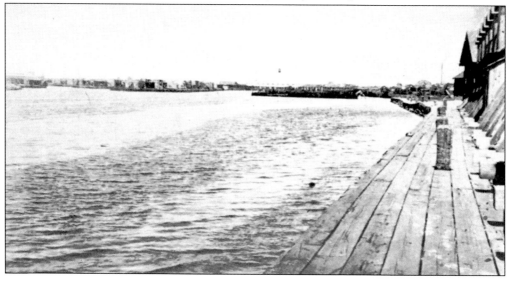

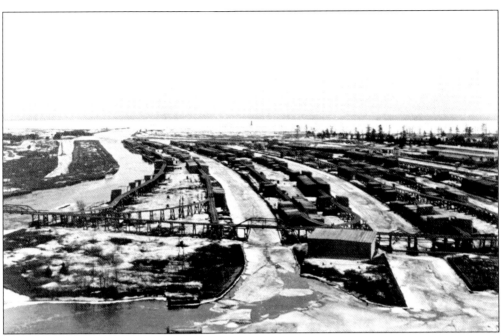

One can see the piles of lumber on several of the slips in Manistique Harbor, which were transferred from the mills to the slips via the tramways. Originally, lumber was moved by horse-drawn cars and later steam-driven cars. The docks or slips were built primary by Swedish immigrants. Looking at the amount of lumber piled on these slips makes one realize how well the slips were constructed in order to handle the giant piles of lumber. The picture above shows the harbor looking out at Lake Michigan while the picture below shows the Chicago Lumber Company mill on the east side of the Manistique River. (Above, Marcus Bosanic Collection; below, Ann Johnson.)

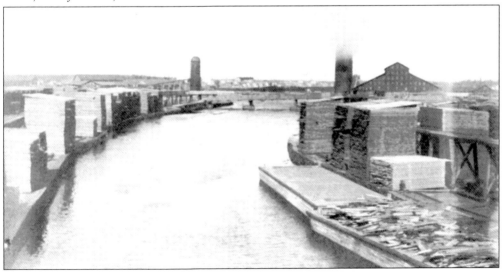

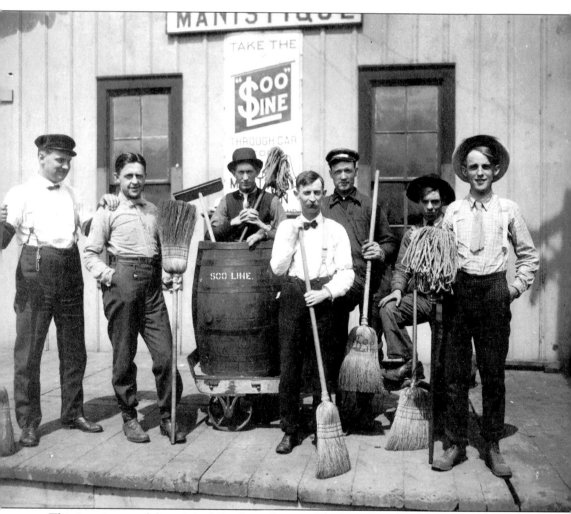

This is a picture of the original Soo Line depot in Manistique with its employees. A new, very modern depot was built in 1921 and considered one of Manistique's showplaces. It served both the Soo Line and Ann Arbor Railroads. The Soo Line's official name was the Minneapolis, St. Paul and Sault Ste. Marie Railroad and was built through Manistique in 1888. The Soo Line stayed solvent for 50 years before conditions sent it into receivership in 1938. By the 1940s, it was back in business but, since that time, has gone through several ownerships. As part of the Wisconsin Central Railroad, it ceased passenger service and carried only freight. The following is an incomplete list of past employees of the Soo Line: telegraphers were Cecil Moore, Dell O'Brien, Ray Besner; warehouse agent Tom Anderson; office clerk Charles Hansen; trackmen and section crew, Claude O'Neil, Paul Dragos, Dick Burnis, Mutzy Schneider, and Peter Wicklund; and coal shed supervisor Bill Ducheny. (Susan Coffey Collection.)

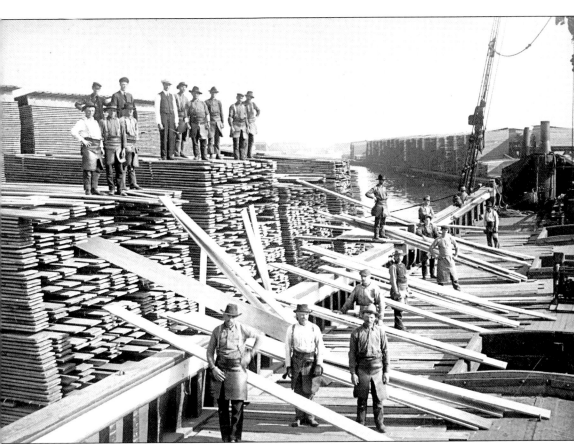

Manistique Harbor's main activity for many years was loading lumber on lumber schooners called "hookers." The men on the right side are standing on the ship's deck and loading the three holds through the open hatches. The workers are all wearing leather aprons to protect their clothing. On top of the wood piles, one can see three well-dressed men who would have been company representatives. In the right background, piles of lumber on another slip can be seen waiting to be shipped. In the distance, one can see storage buildings in the harbor. The ship loaders were primarily Austrian immigrants whose ancestry were primarily Croatian, Czechoslovakian, and Hungarian, since they were part of the Austro-Hungarian Empire prior to World War I. (Clint Leonard Collection.)

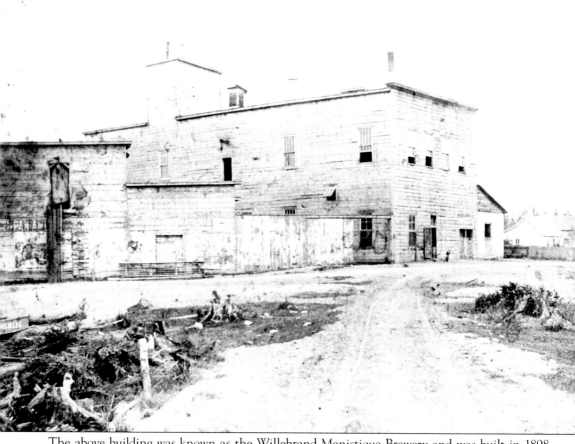

The above building was known as the Willebrand Manistique Brewery and was built in 1898 by the Willebrand family. The beer was called Golden Grain. The location of the brewery was about two miles out of town by the Indian River and the Brewery Dam. A high fence had to built around the brewery to keep the deer out because they would lap beer from the drip trays and end up intoxicated. For thirsty individuals, the brewery had an outside tap with a cup, so one could stop and have a beer before venturing on. Beer was brewed in eight vats that were 10 to 12 feet high. Originally the beer was kept cold in the icehouse with ice cut from Indian Lake in the winter. The icehouse can be seen on the left of the main building. Three of Willebrand's sons worked in the brewery until its sale in 1906 to a group of Detroit investors. In September 1909, two arsonists made a hole in the back wall and poured in kerosene. The result of the fire was no more brewery in Manistique. After the fire, the vats were used by local people as snow rollers. A vat was pulled by two teams of horses to flatten the snow on the roads. (Marcus Bosanic Collection.)

Four

THE FLOOD OF 1920

The most catastrophic event to occur in Manistique other than the fire of 1893 was the flood of 1920. In 1916, W. J. Murphy, who was the publisher and owner of the *Minneapolis Tribune*, organized Manistique Pulp and Paper Company. They began constructing the mill where the original Weston Lumber Company sawmill had stood until it burned in 1907. In addition to constructing the mill, a new dam was built, along with flume walls harnessing the Manistique River for the mill use. Additionally, in 1919, the siphon bridge was constructed with water supporting it, and it was placed it between the two flume sections.

The floodwaters began pouring over the flume walls in the early morning of Palm Sunday, March 28, 1920. The immediate cause of the flood was an ice jam on the Driggs River that had backed the river up. When the jam broke, the water and logs in the river rushed into the Manistique River. Since the winter had had exceptional snowfall along with warmer than normal temperatures and several days of rain, the rivers draining into the Manistique River were already swollen. With the torrent of water, a west bank wall broke, causing water to rush over the flume walls and into the west side of Manistique all the way down Deer Street to Chippewa Avenue. Some damage was also sustained on the east side of the river.

Since the paper mill now owned the power company, the generators were under water, cutting power to the community also. Because the current was so strong, anything in the water's way was picked up and carried to Lake Michigan, causing damage to any buildings in its path. Because the city's water supply came from the Manistique River, citizens were told to drink only well water since the gravity main, which carried water to the city, had broken.

One of the stories coming out of the flood was that one of Manistique's citizens who was crossing Deer Street in a foot of water claimed he stepped on a large pickerel. The pickerel was hand caught and became dinner for the family. Stories have its size from 10 to 30 pounds.

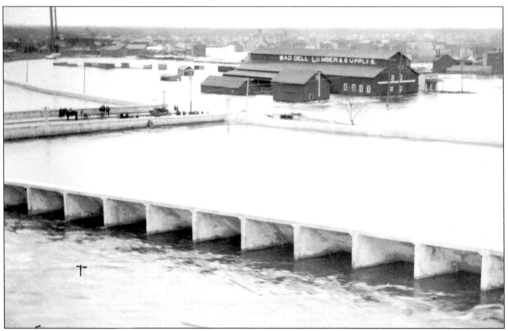

The Waddell Lumber and Supply Company, which was located on the west side of Manistique near the siphon bridge, was in a direct path of the floodwaters. The flood began early on Sunday morning, but by Monday afternoon, the warehouse of the Waddell Lumber and Supply Company had two to five feet of water in it. As the floodwaters gained momentum, they undermined the foundation, swept the lumber stored there toward the paper mill, and damaged the other buildings, and it was only a matter of time before the warehouse collapsed. The lumber company's office building ended up on its side. (Marcus Bosanic Collection.)

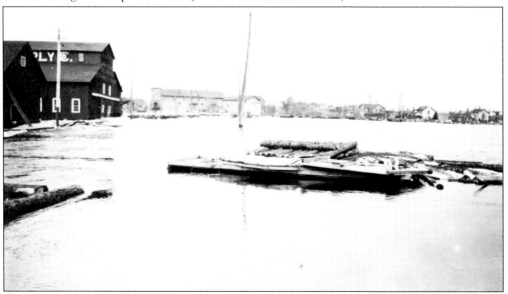

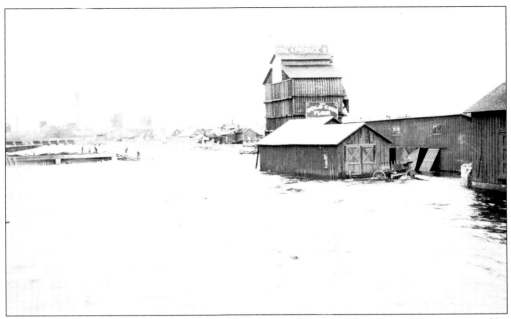

These pictures show the floodwaters around the Riverside Coal and Produce Company owned by E. W. Miller. These buildings were located on the east side of the Manistique River on Elk Street, which also sustained damage from the flood. The swift current carried coal, stocks of grain, and other produce into Lake Michigan. The warehouse and storage buildings had extensive damage to their foundations also. The Consolidated Lumber Company mill and Manistique Handle Factory also sustained damage on the east side of the river. The picture below shows the Riverside Coal and Produce Company from a different angle, along with showing an electrical pole ready to crash into the floodwaters. (Marcus Bosanic Collection.)

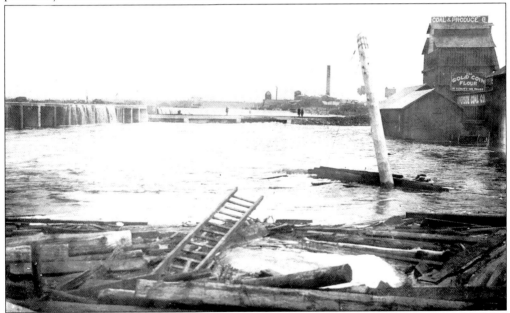

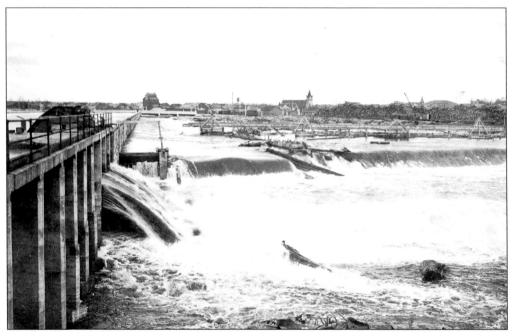

The above picture shows one of the leaks in the flume walls. Both of the pictures show the force of the water pouring out of the Manistique River into the community. By the Consolidated Lumber Company near the mouth of the Manistique River, the current caused a whirlpool, which picked up 100 lumber piles, tossing them into the river and out into Lake Michigan. The whirlpool also tore thousands of tons of sand from the riverbanks near the Consolidated Lumber Company. Part of the tramway between the Consolidated Lumber Company's plant and the Brown Lumber Company collapsed by Monday morning as a result of the foundations being swept away. (Marcus Bosanic Collection.)

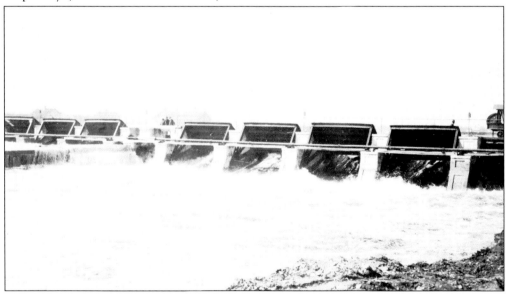

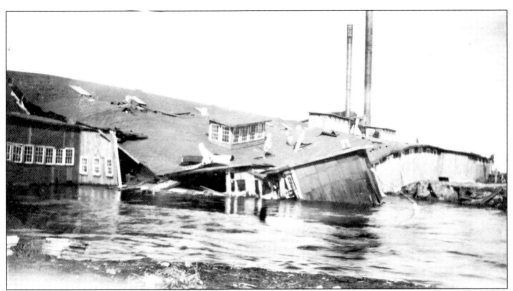

The water pouring out of the Manistique River struck the Goodwille Box Factory, also located on the west side of the river, with tremendous force. The foundations of the buildings were initially undermined, which then caused the floors to collapse and deposited the valuable machinery into the water. Roofs began collapsing, leaving very little of the buildings intact. At the time of the flood, all available space was being utilized for storage of finished products due to a shortage of railroad cars for shipping. The lower picture shows another view of the damage to the Goodwille Box Factory. One can see the railroad tracks covered with lumber and pieces of buildings. (Above, Jerome Halvorsen.)

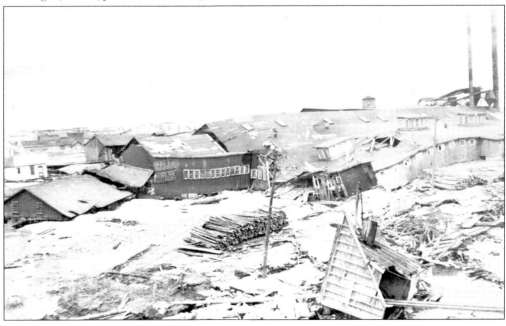

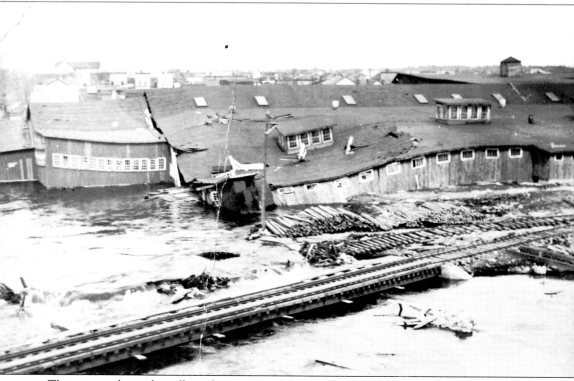

This picture shows the collapsed structures of the Goodwille Box Factory along with the railroad spur to the plant totally torn up. Supplies outside the plant were strewn out into Lake Michigan. The Goodwille's lost 14 million feet of raw material. All the raw material and finished products were carried out to Lake Michigan by the force of the water. David and C. J. Goodwille, both of Chicago and members of the firm, said their loss was more than $120,000. The plant would need to be totally rebuilt, but the Goodwilles were concerned that if the city did not take precautionary measures a flood could reoccur. The Goodwilles wanted assurance that the concrete flume walls containing the Manistique River would be extended before they considered rebuilding their factory. Unfortunately for Manistique, the Goodwilles did not rebuild and later sold the assets that were left to the Robbins Flooring Company, which dismantled the buildings in 1925. (Jerome Halvorsen.)

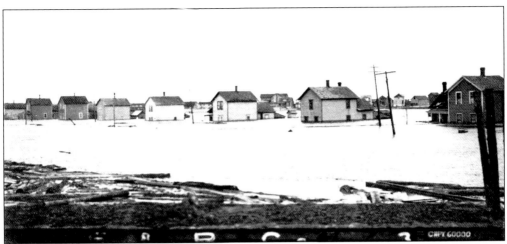

The pictures on this page show homes on Weston Avenue, which was the closest street to the Manistique River on Manistique's west side. Most of the homes here had floodwaters rise to their second stories within a 24-hour span, thus not allowing anyone time to save any of their possessions. Losses ranged from $500 to $4,000 as a result of not only the flood damage, but damage from lumber and logs being driven into their homes and sheds by the rushing water. In the lower picture, one can see the demise of one family's outhouse. (Below, Pioneer Tribune Collection.)

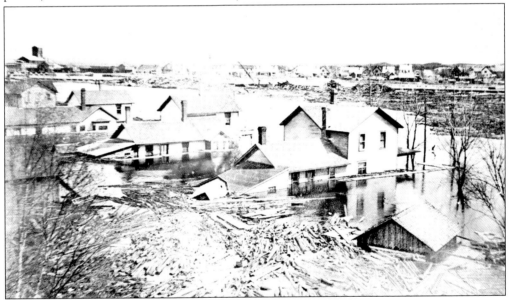

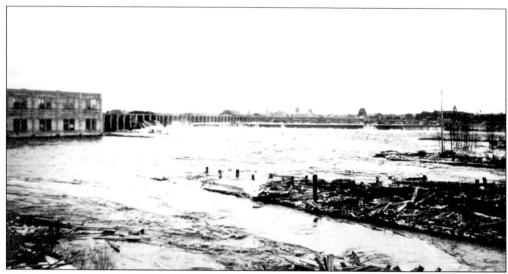

The floodwaters passed through the paper mill breaking windows and upending equipment. The pulp and paper mill company garage, containing a truck; storage buildings; and other structures were swept into the bay. All of the piles of pulpwood in the storage yard also ended up in the river. Fortunately for the mill, their paper machine was located on the second floor and sustained no damage. Since the mill supplied power to the city of Manistique, by Monday the poles carrying electricity fell, so power was out. Temporary electric poles were erected and a dike was built in front of the generating room, which had also been under water, so Manistique's power loss only lasted 12 hours. (Above, Marcus Bosanic Collection; below, Jack and Marian Orr Collection.)

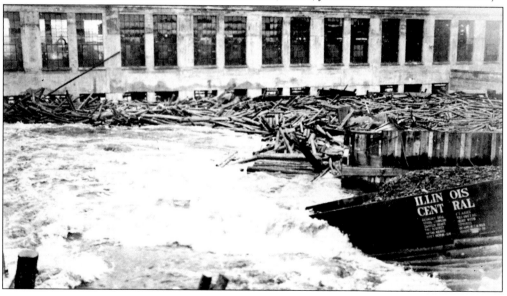

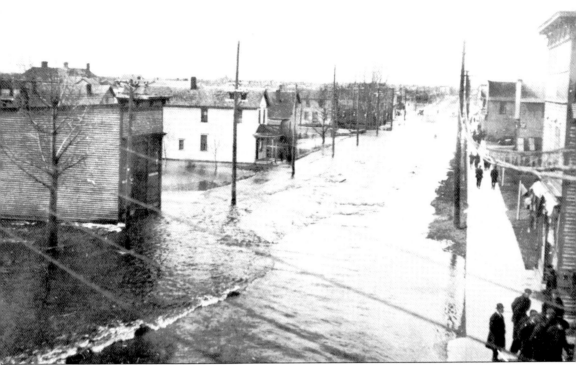

The above picture shows Deer Street with the water swirling down the street. Deer Street was located on the west side of Manistique. The north side of the street fared better than the south side due to the buildings having built-up walkways and being on higher ground. H. Voisine and Sons owned a storeroom and implement company on Deer Street. Their buildings contained farm machinery and with the swiftness of the current, it tore away the foundation causing the floors to collapse. As a result, machinery was washed away. The story of stepping on the pickerel occurred on this street. (Marcus Bosanic Collection.)

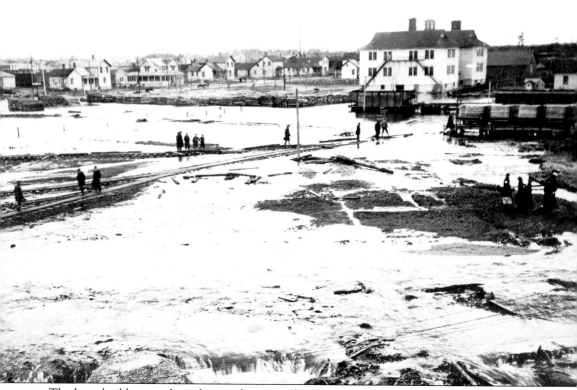

The large building on the right was the west side school that was located on Chippewa Avenue, which was several blocks away from the Manistique River. The school only suffered minor damage since it was built on higher ground. The railroad tracks where some people were walking were also partially submerged. At least 75 homes suffered damage along with the large losses to the business and industrial community. Damages could not be assessed until the floodwaters subsided, which was over a week. (Jerome Halvorsen.)

Five

CITY DEVELOPMENT

By 1901, Manistique was classified as an incorporated city. All areas of the city began expanding, new businesses, industries, churches, schools, and services. After the fire of 1893 had destroyed the then business district along Water, Pearl, and Walnut Streets, businesses moved to Cedar Street. Manistique also had railroads and car ferries. Livery stables were giving way to car dealerships.

Manistique, by 1904, had four newspapers: the *Manistique Tribune* (1882) combined with the *Schoolcraft Pioneer* (1880) in 1896 to become the *Manistique Pioneer Tribune* published by George Holbein; the *Herold*, a Swedish newspaper, published by Nettie Steffenson; the *Courier*, published by J. H. Mc Naughton; and the *Record*. By 1922, only the *Manistique Pioneer Tribune* was still publishing.

By 1892, Manistique had eight churches and schools on both the east and west sides of the Manistique River. Upon organizing the community, the Chicago and Weston Lumber Companies had organized fire departments on both sides of town but the west side fire station burned down shortly after it was built.

In 1912, the Chicago and Weston Lumber Companies sold their assets to the Consolidated Lumber Company, which was comprised of William Crowe and Louis Yalomstein. At that point, the Consolidated Lumber Company owned at least 70 percent of the Manistique area. The company began selling property to individuals instead of having the prior lease arrangements. As a result, the section called Indiantown was eliminated, since the people living there were squatters and had to move their dwellings.

By 1925, the Consolidated Lumber Company ended in bankruptcy and all properties and lumber rights were sold at auction. As resources dwindled and were not replaced, many of Manistique's businesses moved to more affluent areas or merely closed their doors.

This is a view of Cedar Street in 1884 showing boardwalks and soil or mud streets. Erastus, Burton, and Walter Orr (brothers of George Orr) along with Ed Brown formed the Orr Brothers and Company firm. Their business was comprised of four meat markets, a cattle ranch, and a slaughterhouse. Besides the market on Cedar Street, they also had markets on the west side, Southtown, and Thompson. (Jack MacFarlane Collection.)

The large building on the corner of Cedar and Walnut Streets was built in the late 1880s as the Thompson and Putnam Drugstore. A. S. Putnam came to Manistique in 1885 and bought part interest in the Bowen and Thompson Drugstore making it Thompson and Putnam. As a result of the devastating fire of 1893, the drugstore burned to the ground. By that time, Putnam owned the business, rebuilt it, and renamed it A. S. Putnam Drugs. (Marcus Bosanic Collection.)

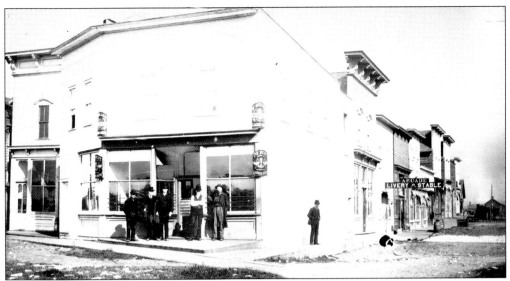

The corner of Pearl and Water Streets, shown above, became known as the Flat Iron Block. The Chicago Lumber Company thought it owned the entire community since its goal was to keep Manistique dry. Daniel Heffron came to Manistique in the 1880s, found a block of Manistique that was privately owned, bought the property, and built a saloon. By the early 1890s, there were 29 saloons located on the Flat Iron Block. (Marcus Bosanic Collection.)

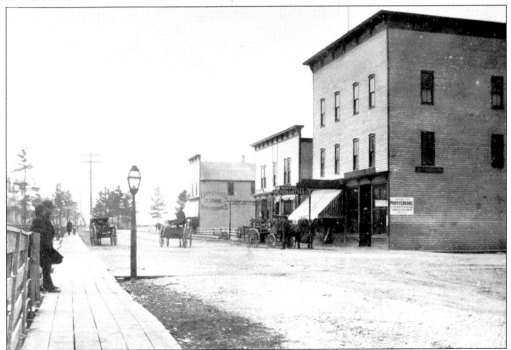

This is a scene of South Cedar Street in 1892. The last building on the right was the Blumrosen Brothers (Moses and Nathan) building, which, because it was made of brick, stopped the fire of 1893 from spreading further south. The Blumrosens came to Manistique in 1880 and pedaled their goods until they had acquired enough assets to build their apparel store. The business continued until 1923. (Marcus Bosanic Collection.)

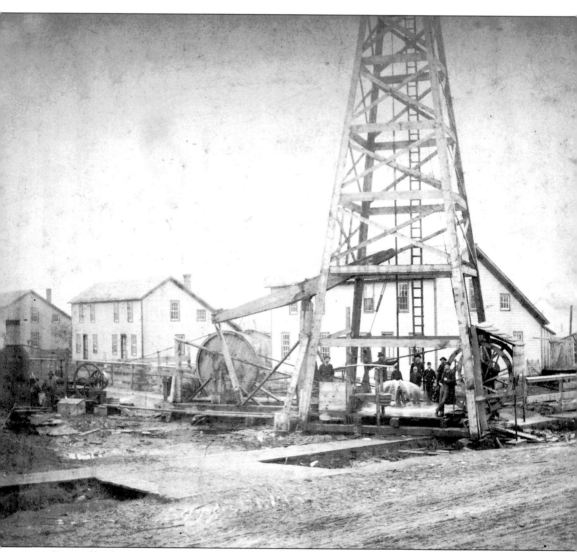

Originally the water supply for Manistique was from artesian wells drilled at different points within the city. The above picture shows how wells were drilled. Water had to be hauled from the artesian wells to the homes for cooking, drinking, and washing. Several draymen hauled water to residents, hotels, and businesses. Mondays, being wash days, kept the draymen very busy. (Charles Howard Collection.)

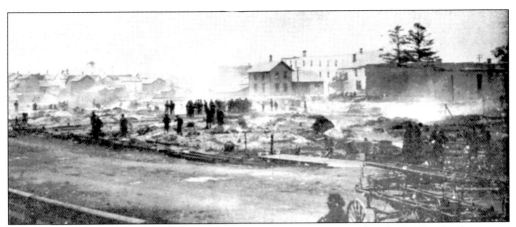

The fire on Friday, September 15, 1893, was called Manistique's "big fire." The fire began on South Walnut Street and spread to both sides of Cedar Street. Since all the buildings except one on Cedar Street were wood, the devastation was extensive. The fire on the west side of Cedar Street stopped only because Blumrosen's store was brick. Due to the wind and power of the fire, the volunteer fire department fought it for five hours, trying to stop it from consuming the residential district. Had it not been for an evening rain, the entire town would have been ashes. Losses from the fire were around $75,000 (several million in today's dollars). As a result of this fire, the city passed an ordinance saying all buildings in the downtown were to be brick buildings. The main business district also moved from Water Street and Pearl Street to Cedar Street. The people of the community began calling for a modern water system along with a fire department that had modern equipment.

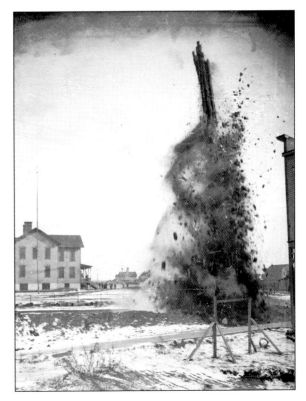

Finally in 1905, the city council passed a resolution to bond for water and sewer. A 16-inch wooden pipe was run from the Brewery Dam on the Indian River to Weston Avenue. This picture is from November 1905 on Cedar Street, showing the blasting involved to install sewer and water lines. (Marcus Bosanic Collection.)

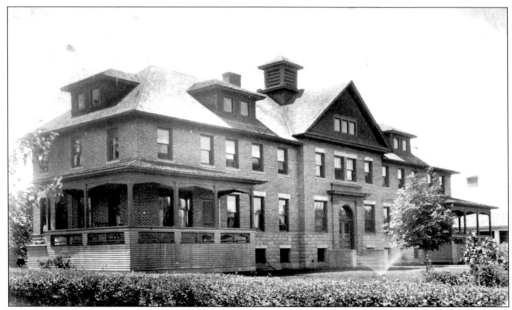

On the far right can be seen a building that was the original county poorhouse, which later served as a tuberculosis sanitarium and was sold and torn down in 1944. (The usable portions of the building were used to construct East and West Burnsvilles.) The above building was built in 1909 and became the new Schoolcraft County Poor House. This building changed names and purposes several times throughout the years. The name changed to the County House in 1915 and became the county hospital in 1920. In 1943, it was leased to the U.S. Army for rehabilitation, and in 1944, it was used as a juvenile detention facility. From 1946 to 1963, it was leased as a convalescent home and the name was changed to the Cloverland Lodge. Later it became Manistique Manor and is currently Elk Street Lodge. (Above, Ann Johnson; below, Adolf Sandberg Collection.)

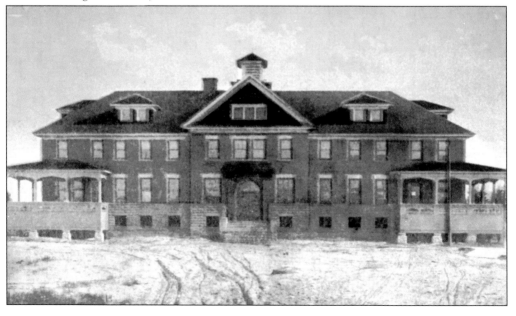

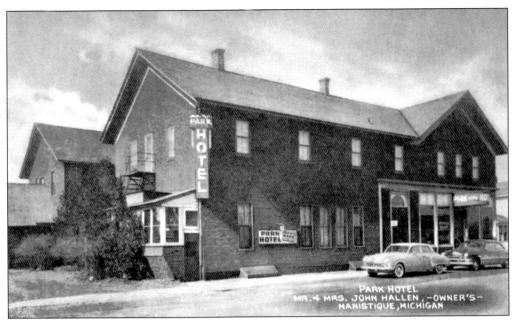

The Park Hotel was one of the first buildings in Manistique, serving as a boardinghouse and office for the Chicago Lumber Company until 1912. The Consolidated Lumber Company also maintained its office there until 1925. John and Elizabeth Hallen, who were newly arrived Swedish immigrants, were offered the building for $1 in 1917. They converted it into a hotel and ran it until the 1960s. (Marcus Bosanic Collection.)

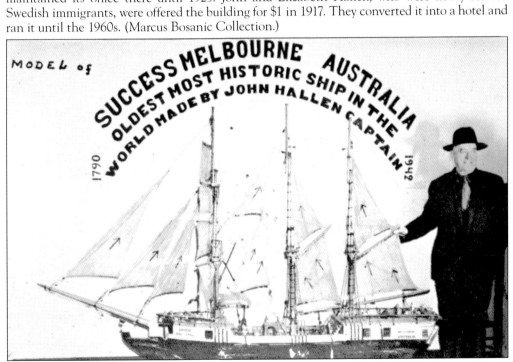

The above picture is of John Hallen in 1942. Hallen's original profession was a woodworker, so while he manned the desk of the Park Hotel, he worked on many projects. This is a scale model of the British convict ship *Success*, which took prisoners to Australia in 1790. The model shows intricate details and was exhibited throughout the United States.

Greetings from

SAWDUST INN
MANISTIQUE, MICHIGAN

Many people can appreciate this postcard since sawdust is a major by-product of innumerable sawmills. Within 10 miles of Manistique in the 1880s, there were at least six sawmills running. Manistique had one Chicago Lumber Company mill (1876), the Weston Lumber Company had two mills (1882 and 1884), the Hall and Buell Lumber Company mill was in South Manistique, the Jamestown Mill in Jamestown, and the Delta Lumber Company sawmill in Thompson. The saws used were very inefficient—circular and gang saws turned 312 feet of wood into sawdust for every 1,000 feet of one-inch boards produced. All the sawmills had silo-type structures called sawdust burners, but their efficiency was low, so it was easier to either dump the sawdust in the harbor or haul it to the mouth of the Manistique River. For many years, people coming to Manistique via boat thought there was an island at the mouth of the Manistique River; it was nicknamed "Abijah's Island" and was comprised of sawdust. Schoolcraft County produced enough lumber to circle the globe 10 times, and as a result, sawdust lined the Lake Michigan shoreline approximately 20 miles on either side of the Manistique River. (Ann Johnson.)

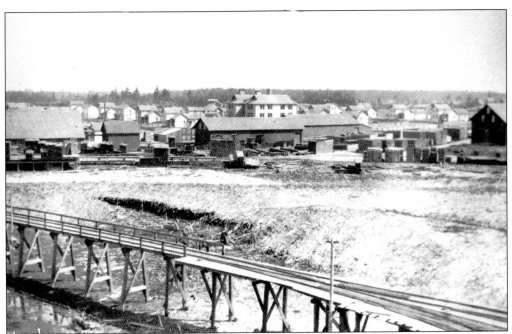

The old Westside School can be seen over the tops of the houses in Manistique. In the foreground part of the tramways used to haul lumber from the mills to the slips can be seen. The Westside School was built in 1881. Prior to that, classes were held in a home on Manistique's west side. Lincoln School was built to replace the Westside School in 1931.

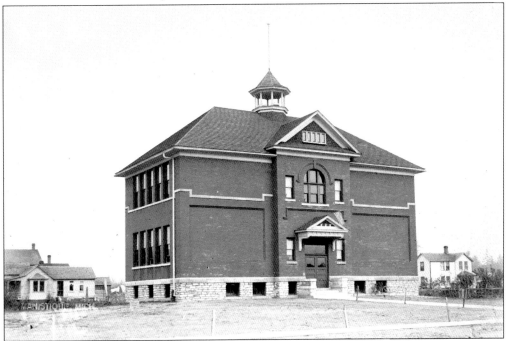

Due to the increase in the population of the community, the Riverside School, which was located on Manistique's west side, was built in 1909. The Westside School was overcrowded so a new elementary school was needed.

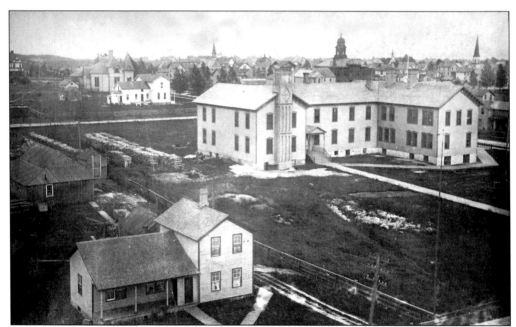

The Central School building was erected in 1881 and had 76 students when it opened for classes. The first high school opened in the same location in 1892 and the first class graduated in 1894. The graduating class of 1894 had two graduates: Oren Quick and George Tucker. An additional grade school was built on the east side in 1903 and was called the Lakeside School. (Pioneer Tribune Collection.)

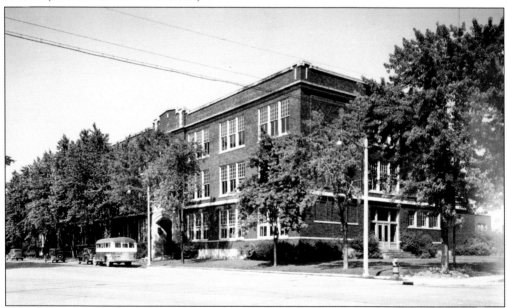

The Manistique High School was built on the same block as the Central School and was erected in 1918. A junior high building was added to the high school in 1931 and replaced the old Central School building. The Hall Stadium for athletics was built in 1937, and in 1939, a stage was widened in the school auditorium and a new classroom called the East Room was built. (Ann Johnson.)

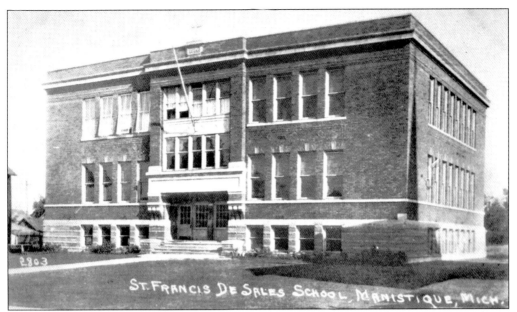

The St. Francis de Sales School was originally a wooden parish hall that was converted into a school in 1901. The original staffing of the school was the Franciscan Sisters of Christian Charity from the Holy Family Motherhouse of Manitowoc, Wisconsin. This picture shows the second school built next to the St. Francis de Sales Church, which has since also been replaced. The school serves students from grade one to grade six and has served up to the eighth grade. Currently the school is staffed by lay teachers rather than nuns.

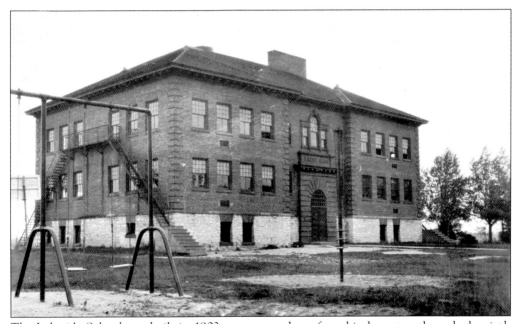

The Lakeside School was built in 1903 to serve students from kindergarten through the sixth grade in what was called the Lakeside section of Manistique. The school was remodeled later, and as a result of a fire, a new Emerald Elementary School opened in 2007.

This building was originally located in Lakeside and served as a school building prior to the Lakeside School being built in 1903. The building was moved to a site in back of the Central School complex and was originally used as the school's domestic science building. After other schools were built at the Central School complex, the building became the American Legion building in 1932. Besides the Legion and auxiliary, it was also used by the Golden Star Lodge, Lion's Club, Rotary Club, and the Scouts. Unfortunately, the building burned to the ground in August 1943. (Above, Marcus Bosanic Collection.)

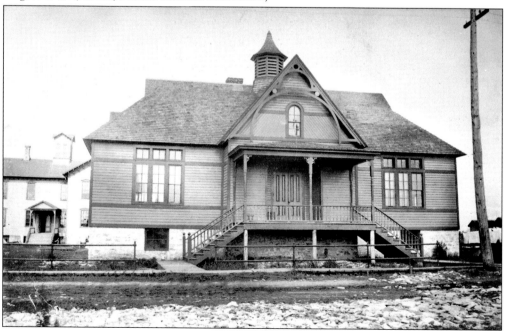

The City Meat Market was originally built as a saloon but because of its close proximity to the Central School complex, Thompson and Weinig were unable to obtain a liquor license. As a result, they opened a meat market. They later sold to Frank Peterson who sold the business to the Smith brothers in 1921. The City Meat Market then became the Central Meat Market.

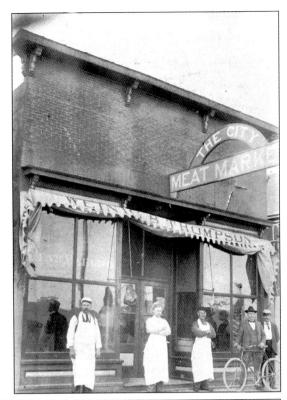

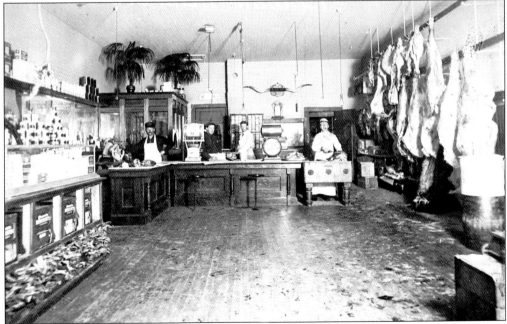

The picture above was the Central Meat Market when it was owned by Frank Peterson. The stools in front of the counter were for the convenience of female customers waiting for their meat to be cut and wrapped. On the left side of the picture, one can see lutefisk piled near the floor indicating the picture being taken during the holiday season.

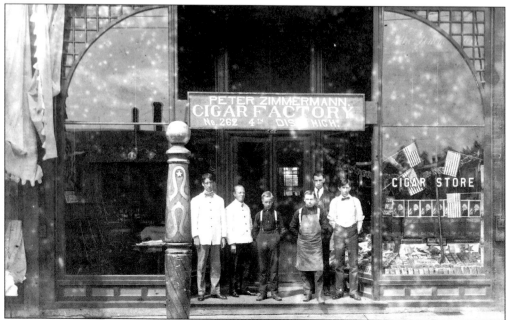

Both of these pictures show the Peter Zimmermann Cigar Factory. The image above shows the outside with the employees, and the one below shows the inside with Peter Zimmermann standing at the counter. Zimmermann emigrated from Baden-Baden, Germany, to Kenosha, Wisconsin. His brother-in-law was a cigar maker, so Zimmermann learned the cigar-making trade and moved to Manistique in 1890 and opened his cigar factory and store. Unfortunately, he became Manistique's first automobile fatality on November 6, 1913, when he veered his bicycle into the path of an automobile. His son, Francis, continued running the business. The business later included a billiard parlor and changed its name to a United Cigar Store. Francis sold the business in 1926 and moved to Kenosha. (Lyle Kotchon Collection.)

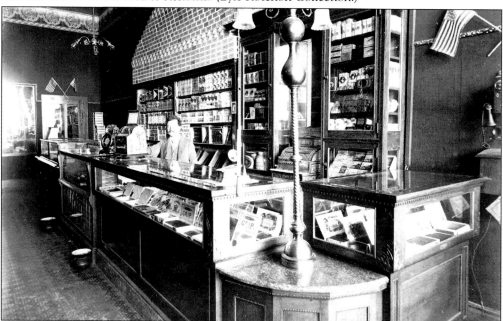

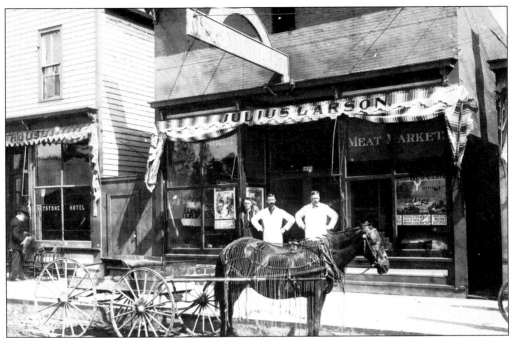

On Manistique's east side were several grocery stores to serve the needs of the local residents. These pictures are of an early grocery store with a horse-drawn delivery wagon out front, and inside meats and sausages were on display for the customers. Julius Larson's Grocery was located on Oak Street and in the 1930s became Vaughan's Grocery. A similar grocery store was the Oliver Hart Grocery, which was located on Furnace Street (later North Cedar Street). Vaughan and Weber's Grocery was located on Cedar Street. Grocery stores and meat markets were located throughout the city for the convenience of the residents. Many customers called in their orders and had them delivered via horse-drawn wagons and later motorized delivery trucks. (Below, David Vaughan Collection.)

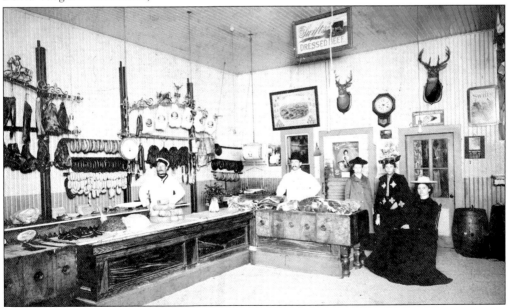

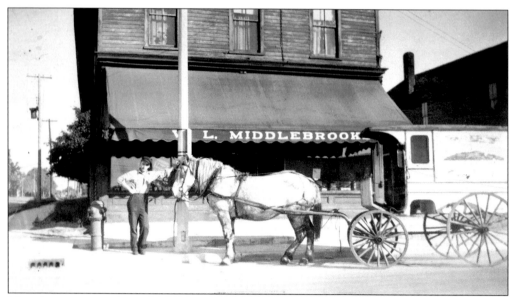

The above picture shows Middlebrook's grocery store with his horse-drawn delivery wagon in front. The picture below shows Middlebrook's new delivery truck in later years. The W. L. Middlebrook Grocery Store was located on the west side of Manistique. Stories of the old-time grocery stores are very interesting in that most products arrived in bulk. Flour could be found in 25-, 50-, and 100-pound bags. Produce such as eggs, butter, and milk were purchased from local farmers along with fresh vegetables in season. Cookies and crackers came in wooden boxes and had to be repackaged by the clerks. Sugar came in 300-pound barrels and coffee came in 100-pound bags and was ground either in the store or many homeowners had their own coffee grinders. Candy came in bulk and was usually displayed in jars or smaller barrels so customers could help themselves. (Above, Astrid Allen Collection.)

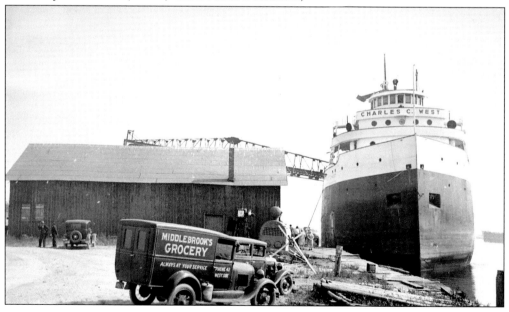

The Ekstrom-Nelson Store was located on South Cedar Street and had apartments or offices on the second floor. The left-hand portion of the store sold apparel and hats, while the right-hand side sold shoes. This store catered to only male customers. The bottom picture shows the interior of the shoe store with benchlike seats lining the center for customers. The sales people wore the normal ware for the time, which was a suit and dress shoes. The height of the stock of shoes is almost two stories with access to the upper tier via stairs located at the back. The amount of inventory was extensive. (Right, Jack MacFarlane Collection.)

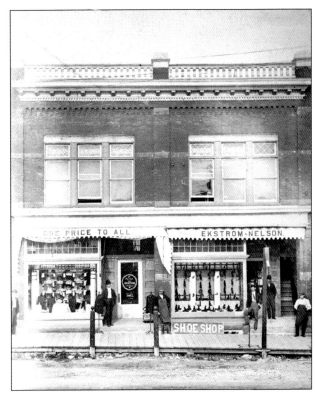

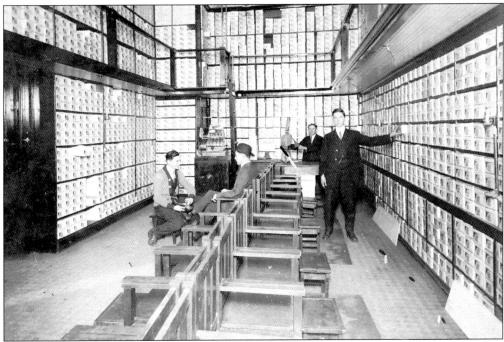

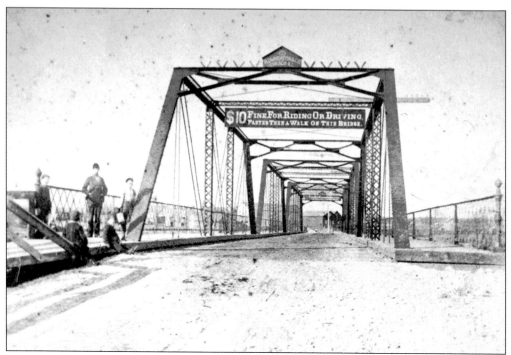

After the old wood bridge called the Red Bridge was condemned in 1890, the iron bridge was built parallel to the old wood bridge. Once the new bridge was completed, the old wood bridge became firewood. Once the siphon bridge was built, the steel girders of the above bridge were used for various building projects throughout the county.

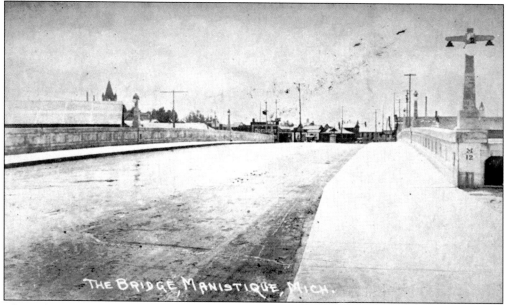

The siphon bridge was built across the Manistique River in 1919 by the Manistique Pulp and Paper Company, which was owned by the Minneapolis Tribune Publishing Company. The roadway itself was four feet below the river, which assisted in supporting the bridge and as a result of that, it was listed in *Ripley's Believe or Not*. (Ann Johnson.)

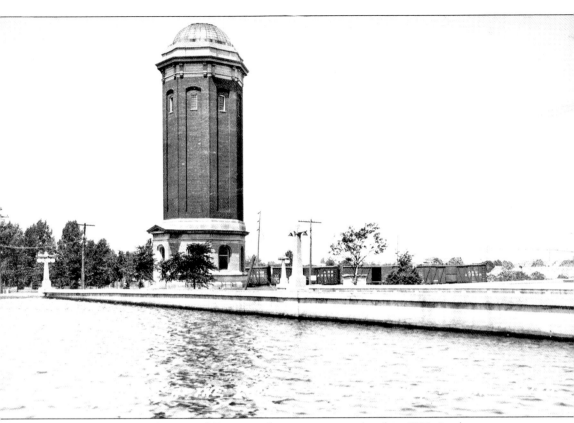

The Manistique Water Tower and Pumping Station was completed in 1922. Inadequate water supplies for the community for industrial, residential, and fire needs caused a bond issue in 1920 for construction of a tower with a 200,000-gallon water tank. The issue was voted on twice in 1920—the first time it was defeated, but finally passed the second time in November 1920. The property by the Manistique River for the water tower was donated to the city. The project also included constructing a 24-inch wooden gravity main between the current dam on the Manistique River to the water tower. Construction began in July 1921 with the primary contractor being Fridolf Danielson. The structure is primarily brick and stands 137 feet high. The building is octagonal and is built in the Romanesque style. The tower remained in operation until 1966 and then was used as the office of the justice of the peace and later for the chamber of commerce. By 1970, it was abandoned to the elements until it was renovated from 2001 through 2004 and reopened to the public in 2005. It was also added to the National Register of Historic Places in 1981. (Jerome Halvorsen.)

This is a view of part of Water Street that later became Arbutus Avenue. In the distance, one can see the Park Hotel. Many of the homes in this area have been removed as a result of the changing of roadways and also the result of business enterprises. The home on the right belonged to Benjamin Gero, it was torn down and became a gasoline station.

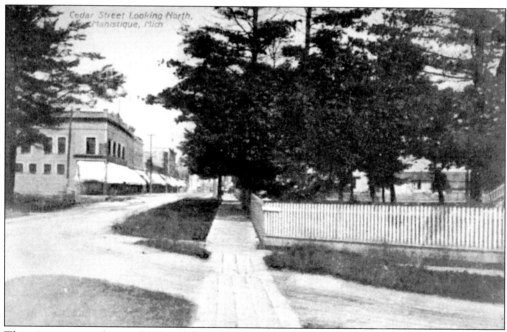

This picture was taken in 1908 and shows the beginning of the business district on South Cedar Street. The boardwalk went down to the docks on the Manistique River. On the right behind the picket fence was Martin Henderson Quick's residence. The dirt street in front of the picket fence was Water Street at that time. (Marcus Bosanic Collection.)

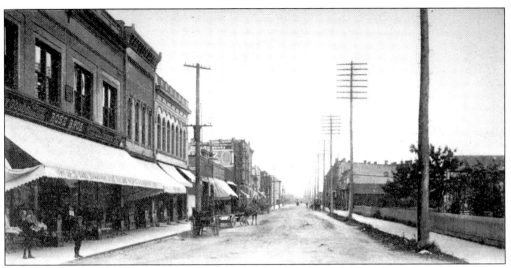

The Rose brothers came to Manistique in the 1890s and had a small clothing store. As their business flourished, they built a two-story building on the corner of South Cedar and Oak Streets. Across the street at that time three homes were located. The store was run by Harry Rose, and it consisted of a grocery department, dry goods department, clothing department, and shoe department. In 1906, a fire engulfed the entire building and destroyed all the contents. The bottom picture shows the ruins of the Rose Brothers store. As a result, the Rose brothers did not rebuild and left the city of Manistique. (Marcus Bosanic Collection.)

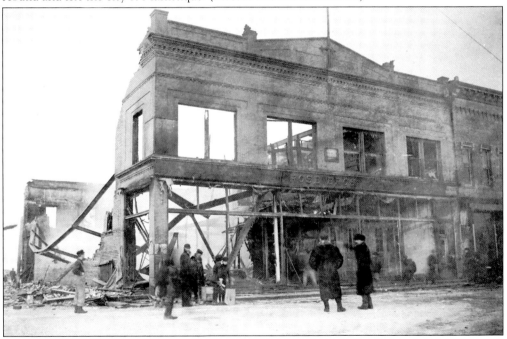

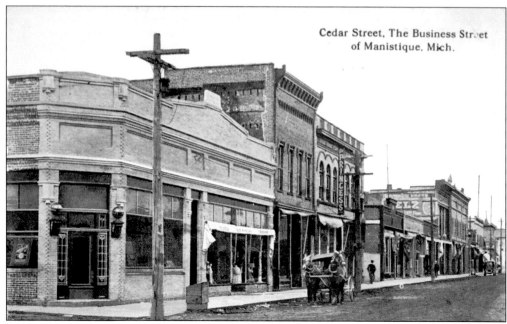

Cedar Street, The Business Street of Manistique, Mich.

The Rose Brothers building was bought by Patrick "Patsy" McNamara, rebuilt, and on the corner housed the McNamara Bar and in the second section, Winkelman's Department Store. The lower picture shows Winkelman's having the entire building. Mose Winkelman came to Manistique in the 1880s and began his career as a peddler until he could set up a department store. His original location was by the Thompson and Putnam Drugstore but it burned down in 1893. Winkelman later moved into the McNamara building. Mose's sons, Isadore and Leon, moved to Detroit and set up business. Finally in the 1920s, Winkelman's moved out of Manistique, and the enterprise had stores throughout the Midwest. (Above, Marcus Bosanic Collection; below, Ellen McNeil McHugh Collection.)

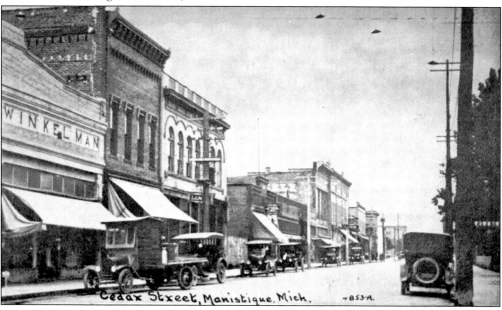

Cedar Street, Manistique, Mich.

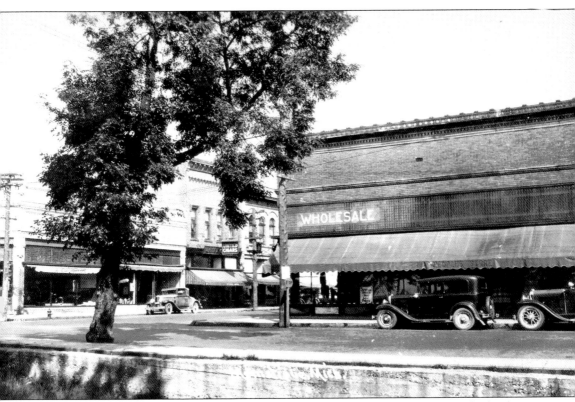

This picture shows a view of the People's Store on Oak Street. Prior to its being built, there were three homes located there. Louis Yalomstein built the People's Store in 1914. This was the largest store in Manistique. Originally it had the following departments: dry goods, clothing, hardware, stoves, ladies' ready-to-wear, millinery, china, sporting goods, and groceries, along with a bargain basement. Cash and carry transactions were handled from a balcony via a basket delivery system that ran from each department to the balcony via cable. Packages were also wrapped in the balcony along with cash and receipts being returned to the departments by basket. (Ann Johnson.)

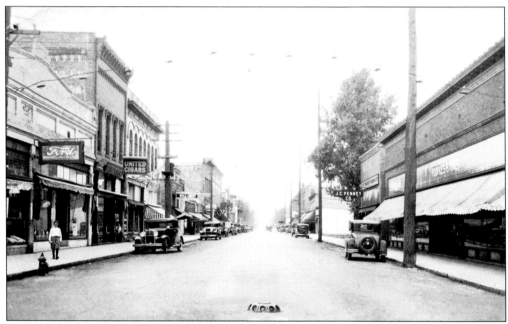

Eventually, after Winkelmans, the corner building became the People's Tractor and Supply Company and then the Ford dealership, which it remains to the current time. Two things of note in the above picture are the electric lights spanning the street and also the grate for the water runoff, which is several inches above the roadway. This picture was taken in the 1920s and also shows the J.C. Penney store next to the People's Store, and across the street is the café in the Gorsche Building, which had housed the Gorsche Bar prior to Prohibition. The bottom picture shows basically the same view except it was taken much later. (Ann Johnson.)

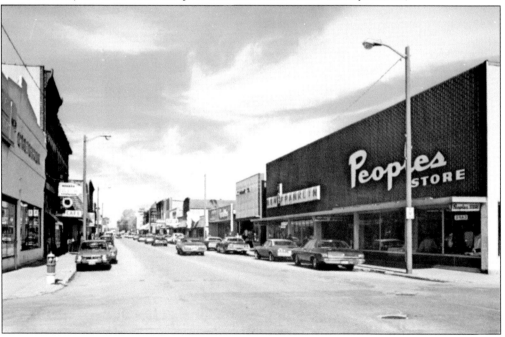

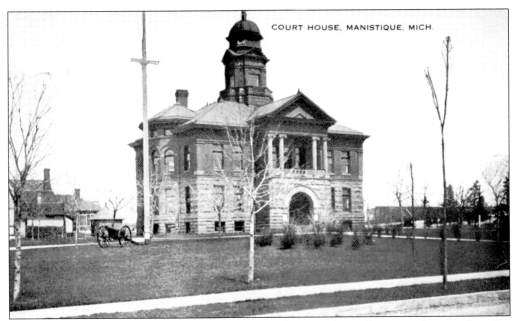

COURT HOUSE, MANISTIQUE, MICH.

This picture shows Manistique's third courthouse. The second courthouse on the same location had burned down in March 1901. The county board sold $20,000 in bonds to construct the new courthouse, which was completed in 1902 and built by W. S. Ramsey, a Manistique contractor. The courthouse was constructed of sandstone and ended up costing $36,767.28. Unfortunately, this courthouse burned to the ground in 1974. (Theresa Neville Collection.)

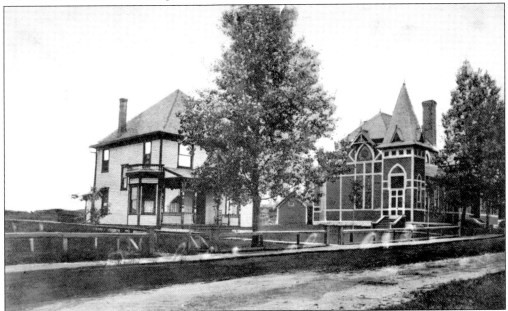

On the back side of the courthouse and jail block can be found the Presbyterian Church and parsonage. The Presbyterian Church was organized in 1887 and the church was completed and dedicated in 1888. Several of the members of the church donated the money for the building and the balance was paid by the Chicago Lumber Company, since several of its board members were Presbyterian. (Adolf Sandberg Collection.)

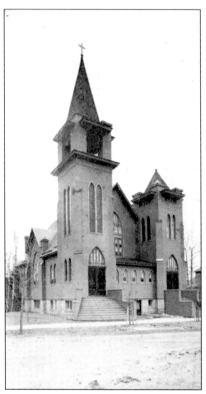

The Swedish Lutheran Church was built in 1885 and eventually became the Zion Lutheran Church. Across the street was the St. Alban's Episcopal Church, which was built in 1895. Other churches in the community were the Norwegian Lutheran Church built in 1892, the Swedish Baptist Church built in 1889, the First Methodist Church built in 1887, and St. Francis de Sales Catholic Church built in 1886. (Pioneer Tribune Collection.)

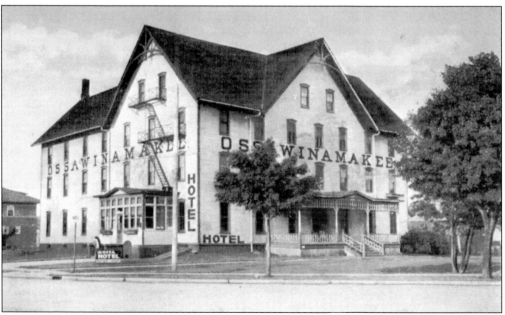

The ownership of the Hotel Ossawinamakee began with the Chicago Lumber Company. In 1915, the Consolidated Lumber Company sold the hotel to Lewis Mallette who ran it for many years. The hotel was in business from 1883 through the 1950s, except during World War II, and was torn down in 1960. During its glory years, many famous individuals stayed at the hotel, including Henry Ford and his friends. (Marcus Bosanic Collection.)

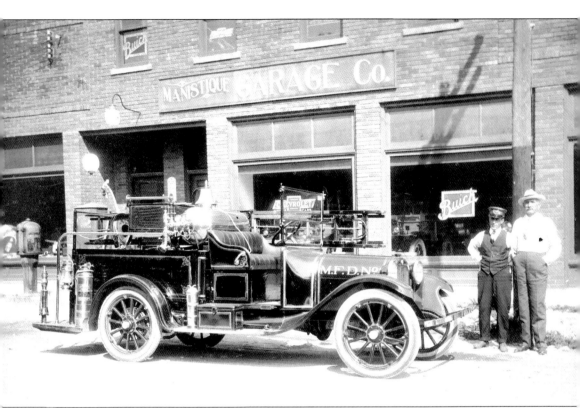

In 1926, the City of Manistique finally purchased a Dodge vehicle to pull the hook-and-ladder truck for Manistique's fire department. Nels Johnson, the owner of the Manistique Garage Company, is standing with Chief Charles Underwood. The Manistique Garage Company building was one of the first buildings built by the Chicago Lumber Company. It began its life as the Star Opera House. The acoustics for productions was amazing since the ceiling was made of bottles. The Star Opera House was used for theatrical productions and later served as an indoor baseball building. Since the local high school did not have a gymnasium, it also served that purpose. The fire department also used it for its annual fireman's ball. H. Booth Fisheries of Chicago bought it and used it for its Manistique office and storage. That company in turn sold the building to Nels Johnson for his Dodge dealership. (Marcus Bosanic Collection.)

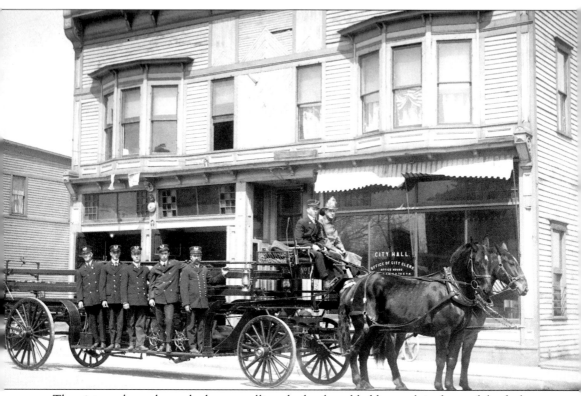

The picture above shows the horses pulling the hook-and-ladder truck in front of the firehouse. The hook-and-ladder truck was purchased in 1885 and turned into a motorized version in 1926. The building in the picture was the second firehouse in Manistique and was located on River Street. This firehouse was built in 1889. Prior to 1903, fire equipment was pulled manually or by any drayman who was passing by. In 1903, horses were bought to pull the fire equipment and were liveried in the back of the building. The two doors were automatic and when the horses were in place, their harnesses dropped from the ceiling. Every day, regardless of if there was a fire, practice occurred at noon and 6:00 p.m.—doors opened and horses and equipment came flying out. The fire horses were also used by the city for street work. By the late 1920s, when the department became motorized, the fire horses were sold. The second story of the firehouse is where the firemen on duty lived and when the fire alarm sounded for a fire, they used the fire pole to reach the first floor. (Jerome Halvorsen.)

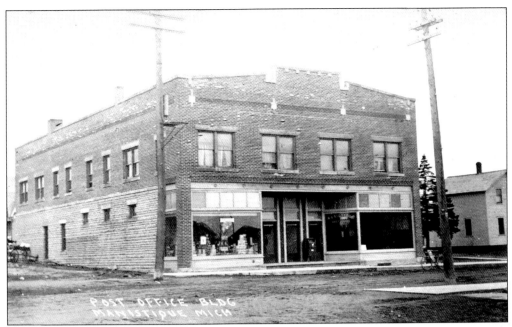

The Sandberg Building, built in 1915, originally housed the Anderson Grocery on the left side and the U.S. post office on the right side. By 1917, the State Savings Bank was organized and moved into the side of the building that had housed the grocery business. The building was located on the corner of South Cedar and Main Streets. (Ann Johnson.)

This picture shows how the post office was set up in the south side of the Sandberg Building. The post office remained there until the new building was built by the Works Progress Administration (WPA) in 1940. Manistique first offered rural free delivery of mail in 1908 but only in Hiawatha Township. Three of the men pictured above were Edmund LaFave, assistant postmaster Victor Remell, and postmaster Fred Griffin. (Marcus Bosanic Collection.)

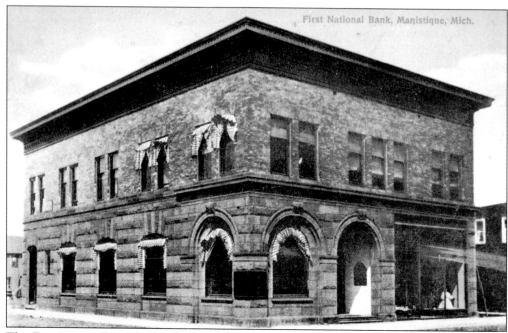

The First National Bank of Manistique opened in 1900 on the corner of South Cedar and Walnut Streets. The bank was reorganized in 1930 and became the First National Bank in Manistique and received its charter in 1934. The upstairs was rented out as offices for professionals. (Adolf Sandberg Collection.)

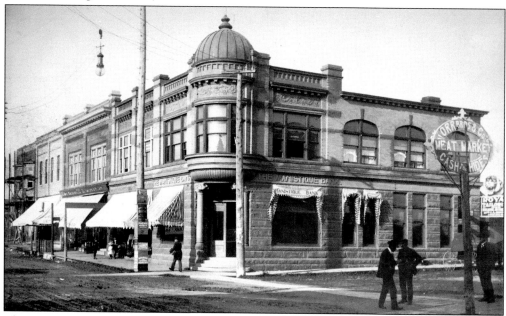

The picture above shows the Manistique Bank Building in 1913. The Manistique Bank acquired the assets of the J. F. Carey and Company Bank in May 1889. The Manistique Bank had several locations before the building above: Pearl Street and River Street. The Manistique Telephone Company's offices occupied the second floor of the building. Unfortunately, the bank closed its doors in the 1930s.

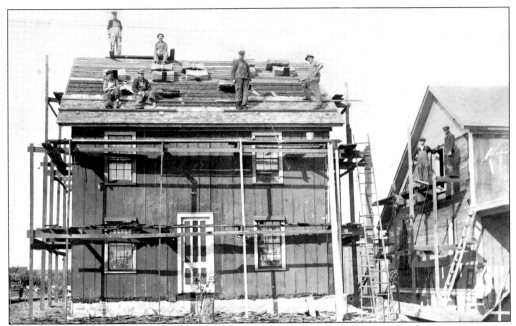

Prior to 1912, the majority of housing in Manistique was owned by the Chicago and Weston Lumber Companies. The majority of homes were duplexes built for the employees and management of the various companies. In 1912, the Consolidated Lumber Company put all its real estate on the market. The picture above shows how the duplexes were cut apart and moved onto separate lots. (Marcus Bosanic Collection.)

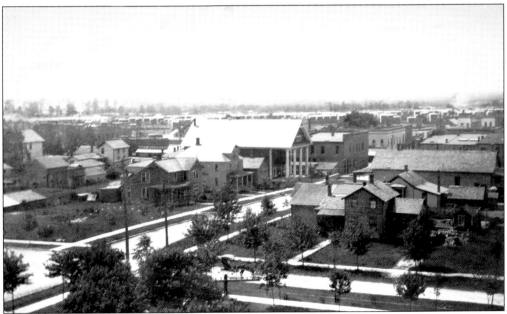

This view of Manistique was taken from the top of the courthouse looking southwest in 1910. The building with columns was the fairly newly constructed Elks temple. Around the top of the picture, one can see all the lumber piles on the slips in the Manistique River waiting to be shipped out. (Jack and Marian Orr Collection.)

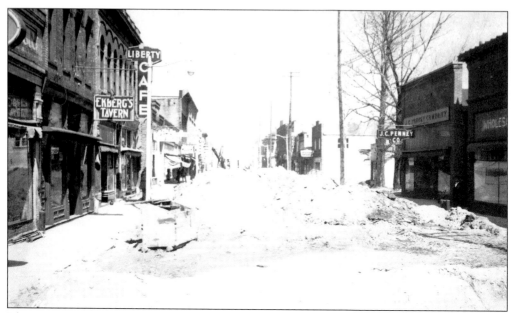

These two pictures show the second block of South Cedar Street from both directions in 1937. As a result of the WPA funds in the 1930s, several projects were completed for the community. A combination of loans, grants, and bonding allowed the project to pave the main streets, put in boulevard lighting, new water and sewer, storm sewers, and new sidewalks. This phase covered four blocks of the business district. Several other residential areas had sewer and water lines extended to them along with sidewalks throughout the city. Another facet of the WPA project was the building of A. F. Hall Athletic Stadium. (Below, Jerome Halvorsen.)

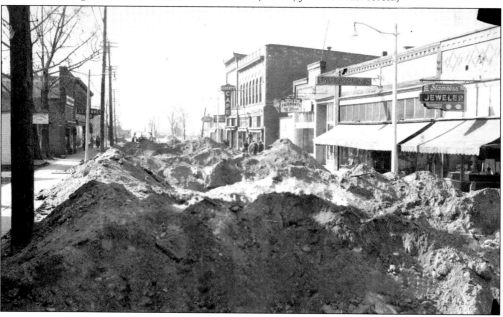

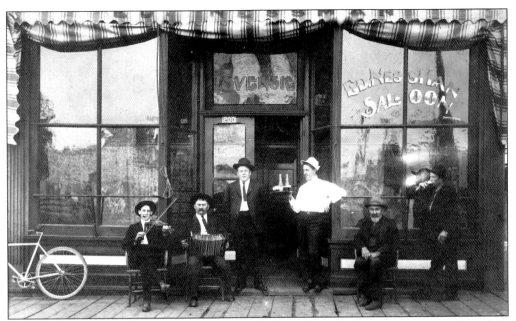

The Flat Iron Block had held all the saloons until the fire of 1893 when bar owners lost their businesses. Once the Chicago Lumber Company began selling property to individuals, they in turn were able to resell property and circumvent the no alcohol clause. The above saloon was the Ed Nessman Saloon on Walnut Street, later becoming the Henry Jahn Saloon. (Normie Jahn Collection.)

The above building was built by the Gorsche brothers next to Nels Johnson's Saloon on South Cedar Street. The Gorsche brothers bought the property from the Rose brothers after their saloon on Pearl Street burned down. Originally saloons advertised themselves as sample rooms and when Prohibition came into being, they became soft drink parlors.

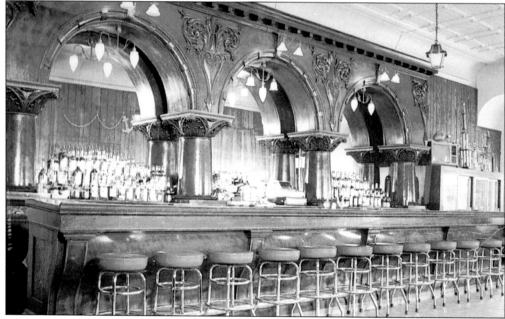

This picture shows the ornate interior of Nels Johnson's saloon. In 1900, he moved from Pearl Street to a new building he had built near the Rose Brothers building. The bar was sold to Emil and Fred Ekberg in 1910. The bar was known as the Ekberg Tavern until 1960, when, under new ownership, it became the Harbor Bar. (Marcus Bosanic Collection.)

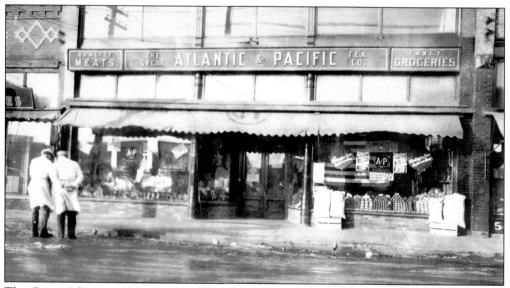

The Great Atlantic and Pacific Tea Company, otherwise known as the A&P Company, had a store in Manistique for many years. The first store was on the corner across from the Chicago Lumber Company Store, then in the middle of the second block (shown above) of South Cedar Street, and its final move was next to the First National Bank. When it closed, the building was torn down for a new First National Bank building.

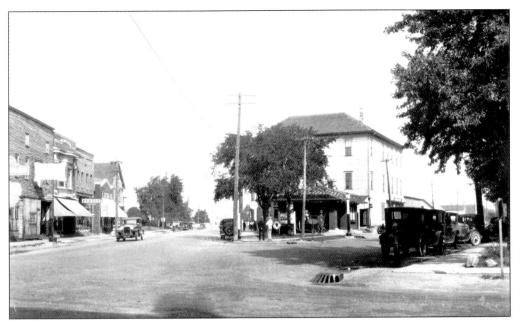

The large building on the right was the Chicago Lumber Company Store, which was built in 1886. At this location, it looked down Cedar Street into the Manistique River harbor. When it was built, retail merchandise was on the first floor, offices and lodge rooms were on the second floor, and the Masons used the third floor.

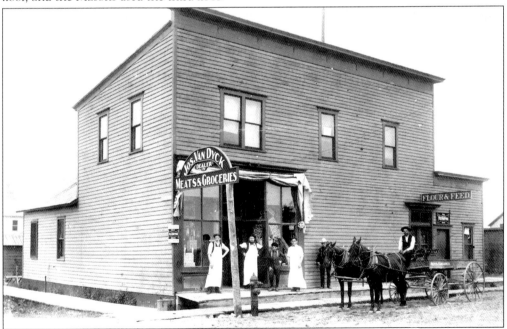

The above grocery store was located on the west side of Manistique in the area called the Forty. Joseph Van Dyck emigrated from Holland to the United States. He moved to Manistique in 1904 and built his store. The above picture was taken in 1911. In order to stock their stores, the many grocers worked together and bought carloads of flour and feed, distributing it among themselves in smaller lot sizes. (Charles Blair Collection.)

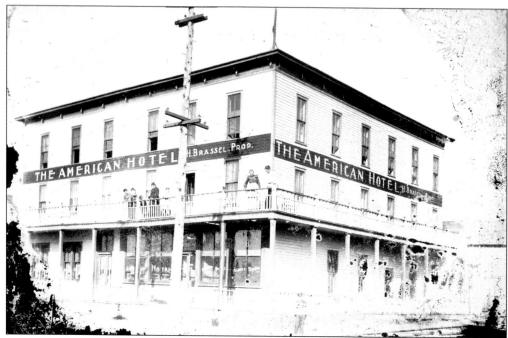

There were several hotels in Manistique by the 1890s. The American House located on the corner of Maple and Oak Streets was originally a three-story structure but as a result of a fire, lost its third story. Some of the proprietors of the American Hotel were August Miller, Henry Brassel, Rod Barnes, and Bill Rowe.

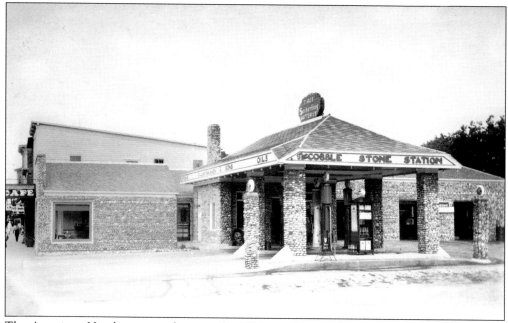

The American Hotel was torn down in the 1920s, and in its place Patsy McNamara built the Cobble Stone Station. In 1923, the McNamara family took over management of the Cloverland Oil Company on River Street and operated three service stations, another one of which was located on the corner of Deer and Fifth Streets.

Another project of the WPA was the building of a U.S. post office in 1940. The post office building was dedicated on August 30, 1940. Within the post office building is a mural that shows lumberjacks at work. The mural was painted in 1940 by David Fredenthal. The murals were part of a federal program administered by the U.S. Treasury Department, which set aside 1 percent of construction costs for original artwork.

The above photograph shows a gathering of Manistique individuals at the Schoolcraft County Airport waiting for the first air mail flight to the county. The date was May 19, 1938. From having mail come via snowshoes and boats to having air mail delivery was an occasion to celebrate. (Marcus Bosanic Collection.)

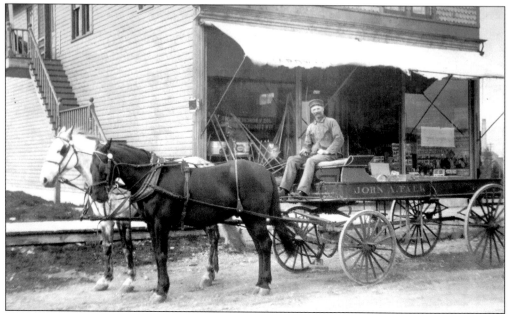

John Falk's Hardware Store was the first store one came to on the west side of Manistique. Falk was particularly fond of his horses, so in the picture below one can see them blanketed, while waiting for various supplies to be unloaded at the Soo Line train station and hauled to different stores in the community, Falk was concerned over the horses becoming chilled. Another business located on the west side was Norton's Westside Grocery originally located on the corner of Deer and Second Streets in 1918. Walter and Hubert Norton built a new building on the corner of First and Deer Streets. The business was later managed by Eldon and Stanley Norton. The Norton grocery was the last neighborhood market to offer home delivery until it closed its doors in 1973. (Below, Jerome Halvorsen.)

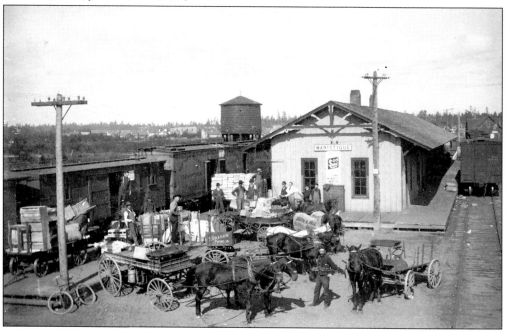

These two views of Manistique were taken from the top of Manistique's water tower. The above photograph shows the west side of Manistique in 1922 and the picture below shows the same view in 1992. In 1922, there were more businesses on Deer Street. Several of these buildings have disappeared from the landscape due to fires and demolition to make room for parking lots. Many of the homes on the side streets in 1922 can still be seen in the 1992 photograph. Falk's Hardware Store building still stands but the rest of the businesses hardly resemble the 1922 scene. (Below, Greg Main Collection.)

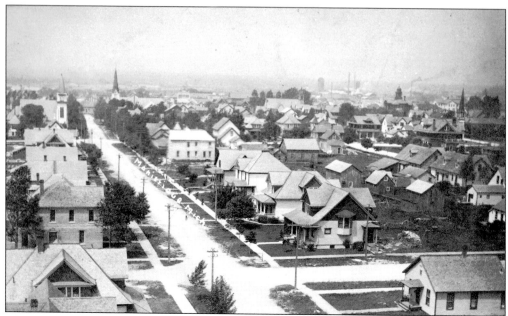

This view of one of Manistique's residential sections was taken in 1909. This section was part of what is known as Lakeside. The photographer climbed the old Lakeside water tower to get this panorama. Telephone poles are visible along the streets, which were dirt and gravel. What looks like sidewalks were actually pine walks. (Jack and Marian Orr Collection.)

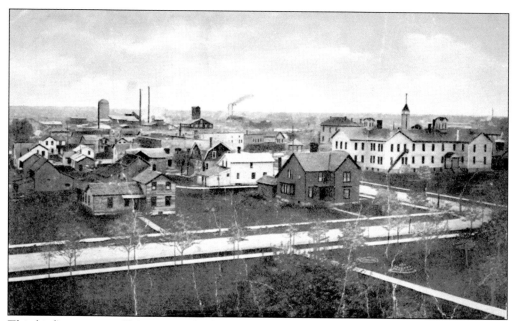

This bird's-eye view of Manistique, looking northwest from the courthouse, was taken in 1917. The large building on the right is the Central School and in back of it the C-L Hardware Store can be seen. In the upper left portion, one can see the Consolidated Lumber Company mill with the tall smokestacks and sawdust burner. Lumber piles can just be made out at the top center of the photograph. (Norma Johnson Collection.)

Six

ENTERTAINMENT

Once the York Staters arrived, the community began to grow in many areas. Culture, education, and religion were extremely important to the Chicago Lumber Company. They not only built sawmills, churches, houses, and businesses, but they made a priority of building the Star Opera House next to the Ossawinamakee Hotel, which housed the entertainers. Since most people were employed six days a week with Sundays off, churches played a major role with not only religious services but also put on various programs for the community. Once railroads came to Manistique, the Star Opera House changed programs two to three times a week. Later several other theaters appeared in Manistique.

Picnics were popular along with excursions to Indian Lake and the Big Spring. Camping, hunting, and fishing were popular activities. Walking or biking to Indian Lake and renting boats and canoes was another summertime activity. By 1889, summer cottages were already being built on Indian Lake. By the 1880s, bicycles became the rage and clubs and races were popular. The first golf course in Manistique was located at the town sand hills but did not fare well. Later a golf course was located at Indian Lake.

Winter activities were skating, sleigh riding, and tobogganing. There were several skating ponds, toboggan hills, and later a ski hill.

Probably the biggest entertainment revolved around parades. Not only parades for Memorial Day and the Fourth of July, but when the circus came to town there were circus parades. Sports teams sponsored by various businesses were very popular along with horse racing.

The Schoolcraft County Fair became another popular area of entertainment in the early 1900s and later was supplanted by the blueberry festivals of the 1940s. Manistique also had several fraternal organizations, a women's club, orchestras, bands, and various clubs.

These two pictures show early Memorial Day parades in Manistique. The parades featured not only the veterans from foreign wars but also the Civil War. Several bands were part of the parades along with the Women's Relief Corps, Red Cross, Catholic Benevolent Association, and Daughters of Veterans. Schoolchildren marched in formation with their teachers along with the 200-member Garden Club. The last unit in the parade was the National Guard unit. Ceremonies at the end of the parade included various speeches, a presentation of pins to all soldiers present, and a calling-off of all service people who died as a result of a conflict. The ceremony ended with taps being played. The early ceremonies took place at the Star Opera House and the majority of the citizens of Manistique attended. (Above, Normie Jahn Collection; below, Martin H. Quick Collection.)

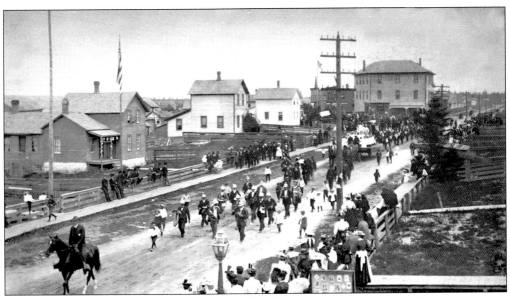

The above parade was probably shortly after the Chicago Lumber Company Store was built in 1886. The Decoration Day parades consisted of the coronet band, Grand Army of the Republic (GAR) veterans in uniform, 116 little girls dressed in white, and citizens of the community. The parade entered the cemetery, placed a wreath on George Fuller's grave and the little girls then tossed their flowers around the grave. Notice the homes on either side have fences, primarily to keep their livestock contained. The street is dirt and the people are standing on the boardwalks. (Above, Marcus Bosanic Collection.)

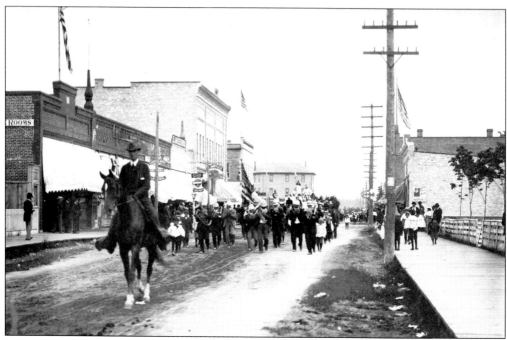

These two parade pictures are from two different time frames. During the time of the Chicago and Weston Lumber Companies' presence, the Fourth of July celebrations were something everyone looked forward to either participating in or watching. A typical Fourth of July celebration from the 1880s started with guns going off before daylight. The morning involved a baseball game between the east and west side mills. The parade began at noon and was led by the Manistique Coronet Band. Also in the parades were mules, horse, wagons, carts, and drays, plus humorous characters and caricatures on hay wagons. The rest of the afternoon was filled with different contests where prizes were given to the winners. At dark, people assembled at the town square for a fireworks display. (Above, Marcus Bosanic Collection; below, Ann Johnson.)

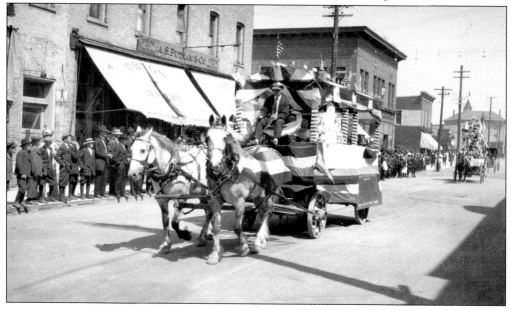

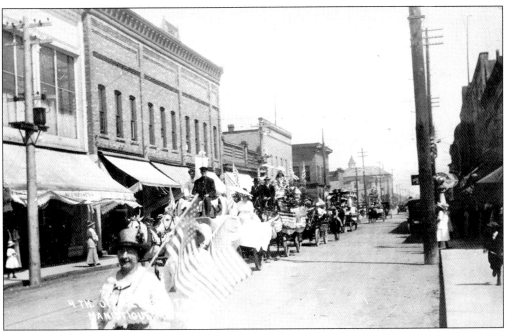

The above picture would have been the early part of the 1900s. The descriptions of the celebrations for the Fourth of July in the Manistique *Pioneer-Tribune* were very different from current celebrations. In 1898, two balloonists were coming to town to do two balloon ascensions, each to be accompanied by a parachute drop from midair. Bicycle races, horse races, a mock battle between the GAR, Sons of Veterans, and volunteers, and catching the greased pig were also additions to the celebration. Prizes for the bicycle races were items such as pants, socks, bicycle suits, golf socks, and sundries. The bottom picture shows a circus parade coming from the harbor to the town square where they would set up their tents. The town square was located right before the bridge on the Manistique River.

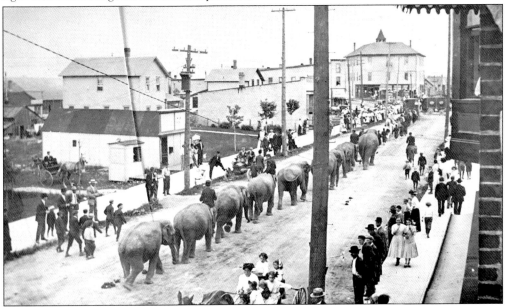

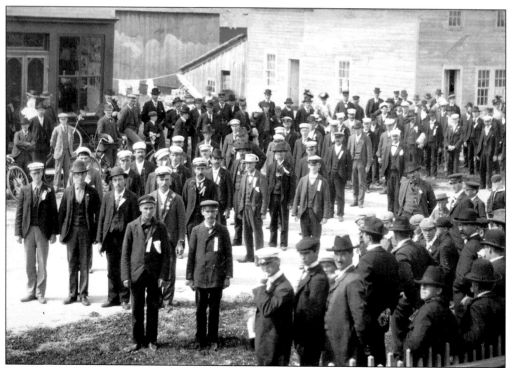

Manistique and Schoolcraft County have played many large roles in many military conflicts both on the war front and the home front. Many of the early pioneers to the community were Civil War veterans. The picture above shows the volunteers from Manistique marching down the street and getting ready to leave to fight in the Spanish-American War. (Marcus Bosanic Collection.)

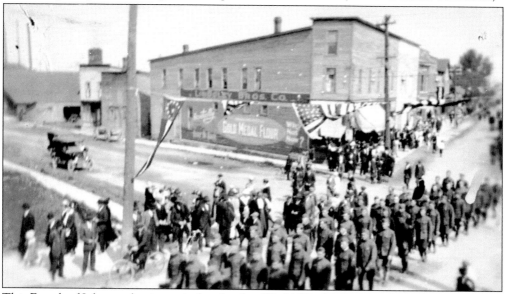

This Fourth of July parade picture is shortly after World War I. The picture was taken from the Sandberg Building on the corner of South Cedar and Main Streets. One can see buildings also on the corner of River and Main Streets, but the road conditions still appear to be dirt with boardwalks for the spectators.

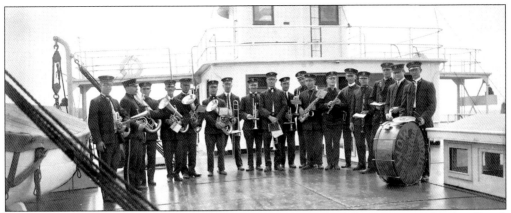

Manistique's original band was called the Coronet Band, which later became the City Band. Another band was the Woodmen of the World (WOW) Band, which was actually sponsored by an insurance company from Omaha. The WOW Band was formed in 1916 and traveled to many of the WOW camps where they competed with other WOW bands. By 1947, only the Manistique Municipal Band remained (pictured below). Several other musical groups also existed throughout history, since dancing was a popular pastime. Some of the groups were the Janssen Piano Band, the Country Club Orchestra, Todd's Orchestra, the Art Owens Orchestra, and the Gorsche Orchestra. Many of these small orchestras played with the traveling road shows that appeared at the opera houses. (Clint Leonard Collection.)

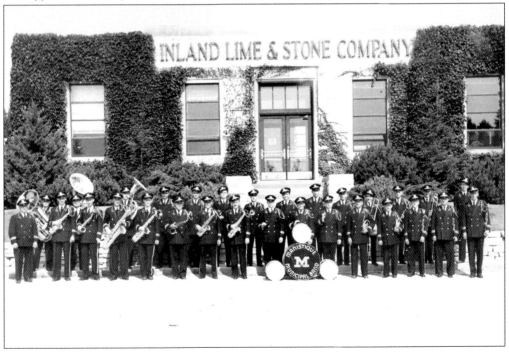

The top picture shows some of the buildings that were built originally in 1911 to house the Schoolcraft County Fair. The fairs of yesterday included airplane flights, horse races, horse-pulling contests, ball games, band concerts, a circus or carnival, several agricultural exhibits, and displays by local merchants. The categories for exhibits were horses, cattle, sheep and swine, poultry, grain and field crops, vegetables, fruits, canned fruits and vegetables, baking, fine arts, domestic handiwork, school exhibits, and flowers. The picture below shows one of the first airplanes to fly at the fairgrounds. The fair closed in 1933. During the 1940s, Manistique had blueberry festivals, which included pie-eating contests, wrestling matches knee deep in blueberries, band concerts, races, and parades. (Above, Marcus Bosanic Collection; below, Normie Jahn Collection.)

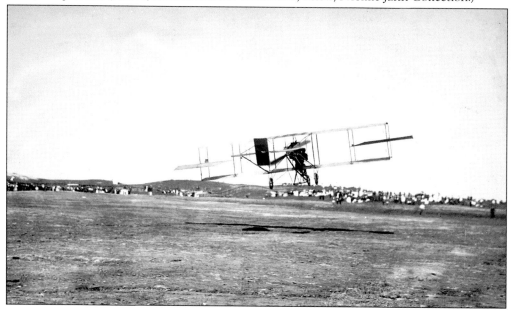

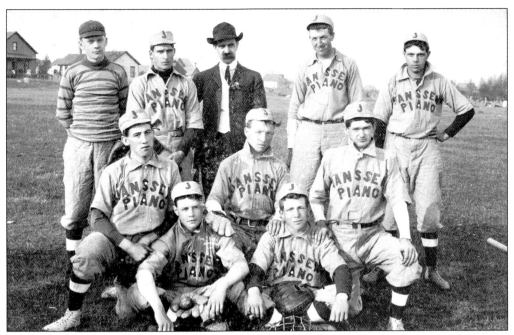

Sports played a large role in the community. Many baseball teams were sponsored by local merchants and competed not only in the community city league but also against teams throughout the Upper Peninsula. The above team was a 1905 group sponsored by the Janssen Piano Store. Manistique also had an indoor baseball team that played in the original Star Opera House. (Clint Leonard Collection.)

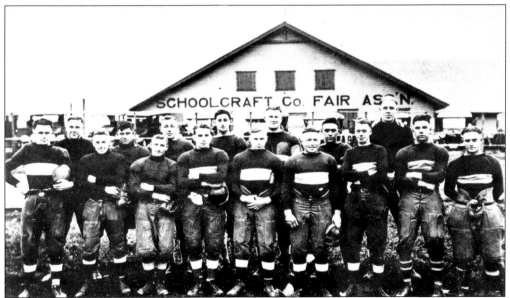

Football has always played a role in the community. Above is a 1920s high school football team in front of the Schoolcraft County Fair Association Building, which is where they initially practiced before a stadium was built. Another major sport during the 1930s was city league basketball. Many teams played against the various Civilian Conservation Corps (CCC) camp's basketball teams. (Marcus Bosanic Collection.)

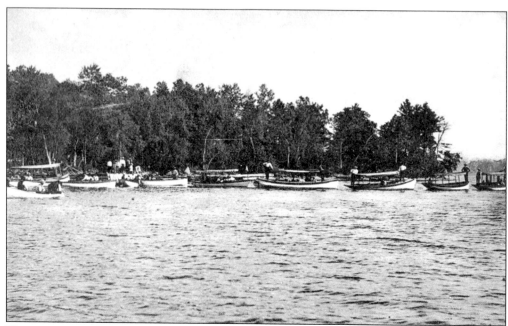

The area pictured above is Arrowhead Point on Indian Lake. Arrowhead Point also had a shed that was used for picnics and parking bicycles. During summer months, by walking, biking, horse conveyance, and later vehicles, the people of Manistique went to this area for picnics and swimming. The picture above shows the boats that are docked at Arrowhead Point waiting to be rented on a nice summer day. The picture below shows the type of path one used to get to Indian Lake. (Above, Ann Johnson; below, Marcus Bosanic Collection.)

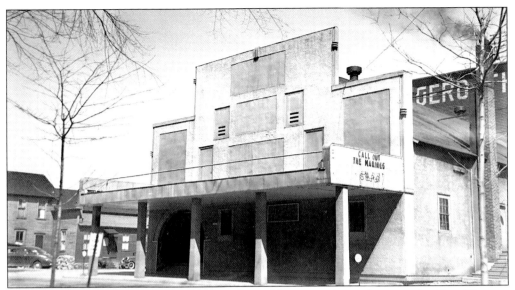

Manistique's original opera house, the Star Opera House, was located next to the Gero Theatre. Benjamin Gero bought the building above in 1904. Gero changed the name from the Hancock Brothers Opera House to the Manistique Opera House. In 1916, Benjamin Gero Jr. and his brother Paul converted it into the Gero Theatre for screening silent movies, and in 1929, talking pictures were introduced and shown. In 1941, the theater became the Oak Theatre under the ownership of J. L. Le Duc. Many other theaters came and went in the community, such as the Princess Theatre, which was located on South Cedar Street and in business from 1907 to 1917. The Rex Theatre and Photo-Play Theatre also had short life spans. The Cedar Theatre opened in the 1930s and ran until the 1950s. The picture below shows the inside of the Gero Theatre when it was still an opera house. (Benjamin Gero Collection.)

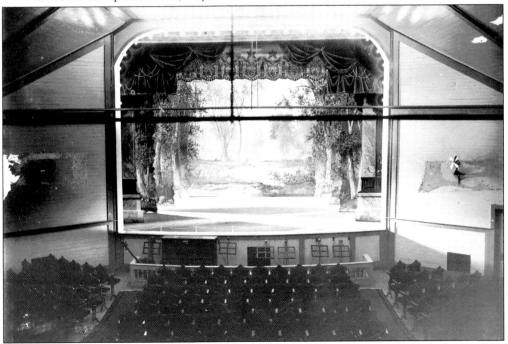

In 1898, the above whist club converted its club to the Women's Reading Club with a membership of 17. Initially the membership was limited to 25, and in order to join, one needed to submit an application, be approved, and pay annual dues of 35¢. In 1916, the group joined the General Federation of Women's Clubs and changed its name to the Manistique Women's Club. The club has supported many philanthropic causes since its inception.

Manistique in its early days had several fraternal organizations. Pictured above is the Knights of Pythias Evergreen Lodge. The female counterpart was the Pythias Sisters. The Knights of Pythias had at one time 100 members but ended its role in Manistique in 1926. The Masons, Eastern Star, Odd Fellows, and several immigrant groups had organizations in Manistique. The survivors of this group are the Masons and Eastern Star. (Susan Coffey Collection.)

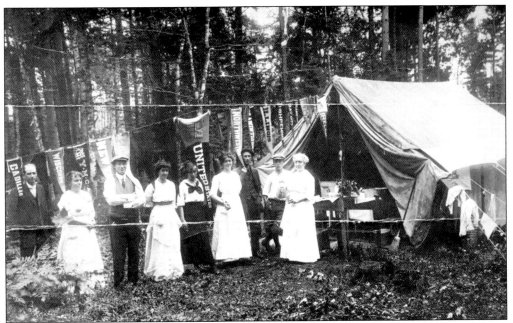

This is a camping scene from 1911. Most of the camping was at Indian Lake on Harrison Beach or along the Indian River, where many individuals also had boathouses. Often times, the tents would be put up in two rows and left for the summer season. Residents would travel to their tent sites on weekends or for their vacations.

Beginning in the 1890s, bicycles were replacing horses as the way to travel. Bicycle clubs were formed and long-distance racing was also the rage. The picture above is the bicycle club at Indian Lake, probably at Arrowhead Point where a shelter had been built for bicycles. Tandem bikes were also popular, but women had very strict dress codes in that only their ankles could be exposed. (Marcus Bosanic Collection.)

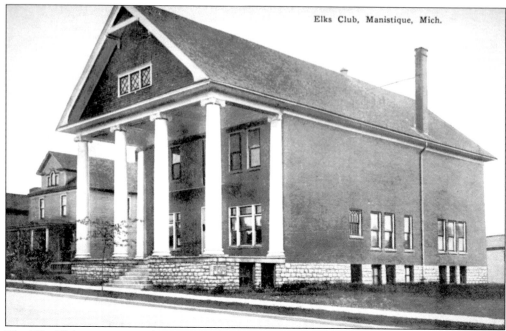

The Elks Club was organized in 1901 and the Elks temple was built in 1909. The club continues to survive as a club. The top floor is the meeting room for the Elks, the middle floor contains the bar, and the lower level has a bowling alley and gaming area. It was said that many a property changed hands in the poker games at the Elks Club. (Ann Johnson.)

The first golf course in Manistique was developed in the 1920s by Benjamin Gero Jr., had five holes, and was located at the sand hills. The Indian Lake Golf Course came to be in 1927 as a private venture. The property was originally purchased from Oren Quick and was 215 acres. Eventually it became a stockholder company, which has continued to offer golf enthusiasts a beautiful course. (Martin H. Quick Collection.)

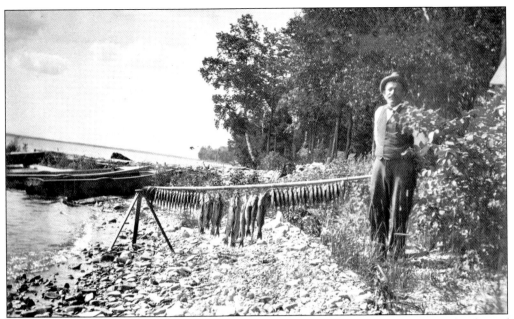

The Manistique area abounded with opportunities for both hunting and fishing. The days of limits on game or licenses obviously did not exist when one had a postcard showing the number of fish on the pole in the picture above. As a result of no limits, 200 or 300 fish were caught on a daily basis by as few as five men. The picture below shows an 1890 hunting party. It is quite apparent the women were the ones to stay in camp while the men and boys went hunting with the dogs. Interestingly, limits were finally placed on deer in 1915, allowing only one deer to be shot per person, but as mentioned with fish, 12 deer per person was not unusual prior to 1915. (Below, Martin H. Quick Collection.)

One of the most popular places for picnics and excursions was to go to the Big Spring at Indian Lake. Initially, one crossed Indian Lake and then hiked to the Big Spring, but later, there was a narrow-gage railroad that took people from Thompson to the Big Spring. In 1889, a Mr. Shaw of Manistique began regular trips with his yacht on Indian Lake three times a week with pickups at three locations. The Big Spring is an oval pool area that measures 300 feet by 175 feet and has a depth of 40 feet. Initially, people built rafts so they could go out into the pond. The top postcard shows the first raft used and the bottom postcard shows the Knights of Pythias on an excursion to the Big Spring in 1910.

Kitchi-Tiki-Pi

(BIG SPRING)

The sand is called by the Indians . . .

TSHI'SAQKA ASES'KI
(Juggler's Sand)

The water is called by the Indians . . .

TSHI'SAQKA AIA'NIB KIME'WAN
(Juggler's Laughing Rain)

Both Sand and Water are Magical.

The sand and the water from Kitchi-tiki-pi are used thus: The sand as an all around good luck powder, and the water as a prevention against Bad Spirits.

The sand, when mixed with a kind of bark the Indians smoked, becomes . . .

TAKOSAVOS,
"Love Powder"

The Big Spring was also used as a dumping area for trash. As a result of the efforts of John I. Bellaire, Kitchitikipi became a state park. Much of the land around the Big Spring was owned by the Palms Book Land Company and as a result of its sale of the land in 1926 to the state, the Big Spring picked up its third name—Palms Book State Park. John I. Bellaire spent his life in Manistique advertising the spring as shown by the label above. He sold both water and sand in his five-and-dime store, claiming they had magical powers. Bellaire also had a book published creating the story of the Big Spring. Basically, its a story of a young chieftain who is trying to prove his love to a Native American maiden, and he drowns in the spring. Supposedly, he returns in the form of a white deer. The above label was attached to packets of sand and water sold by Bellaire.

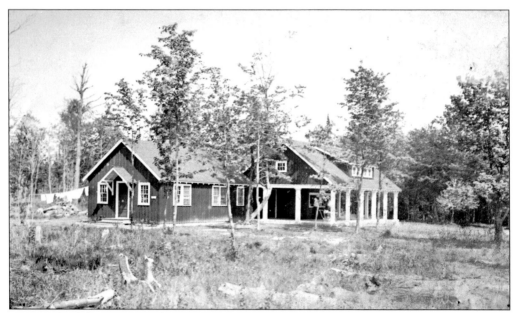

As a result of the CCC and the WPA, several projects were undertaken in Schoolcraft County. The picture above shows the original ranger's quarters and concession stand that were built in the 1930s by the CCC at the Big Spring. Below is the more modern raft that was also built by the CCC so people would be able to view the bubbling springs and the large brown trout with more stability than the earlier rafts. Palms Book State Park has remained a favorite attraction and picnic area with both local citizens and tourists. A popular tradition is to throw a coin in the water for good luck. (Below, Ann Johnson.)

BIBLIOGRAPHY

Burkhardt, D. C. Jesse. *The Ann Arbor Railroad.* Charleston, SC: Arcadia Publishing, 2005.

Crowe, William S. *Lumberjack: Inside an Era in the Upper Peninsula of Michigan.* 3rd ed. Edited by Lynn McGlothlin Emerick and Ann McGlothlin Weller. Skandia, MI: North Country Publishing, 2002.

Hornstein, Hugh A. *The Haywire: A Brief History of the Manistique and Lake Superior Railroad.* East Lansing, MI: Michigan State University Press, 2005.

Manistique: The Live Wire City of Upper Michigan. Manistique Commercial Club, 1913. Reprint, Manistique, MI: Schoolcraft County Historical Society.

Orr, Jack. *Lumberjacks and Other Stories: Memories of Manistique.* Manistique, MI: self-published, 1983.

———. *Lumberjacks and River Pearls: Memories of Manistique.* Manistique, MI: Pioneer-Tribune, 1979.

A Souvenir of Manistique, Mich. Manistique Harold, 1902. Reprint, Manistique, MI: Schoolcraft County Historical Society, 1992.

Discover Thousands of Local History Books Featuring Millions of Vintage Images

Arcadia Publishing, the leading local history publisher in the United States, is committed to making history accessible and meaningful through publishing books that celebrate and preserve the heritage of America's people and places.

Find more books like this at
www.arcadiapublishing.com

Search for your hometown history, your old stomping grounds, and even your favorite sports team.

Consistent with our mission to preserve history on a local level, this book was printed in South Carolina on American-made paper and manufactured entirely in the United States. Products carrying the accredited Forest Stewardship Council (FSC) label are printed on 100 percent FSC-certified paper.